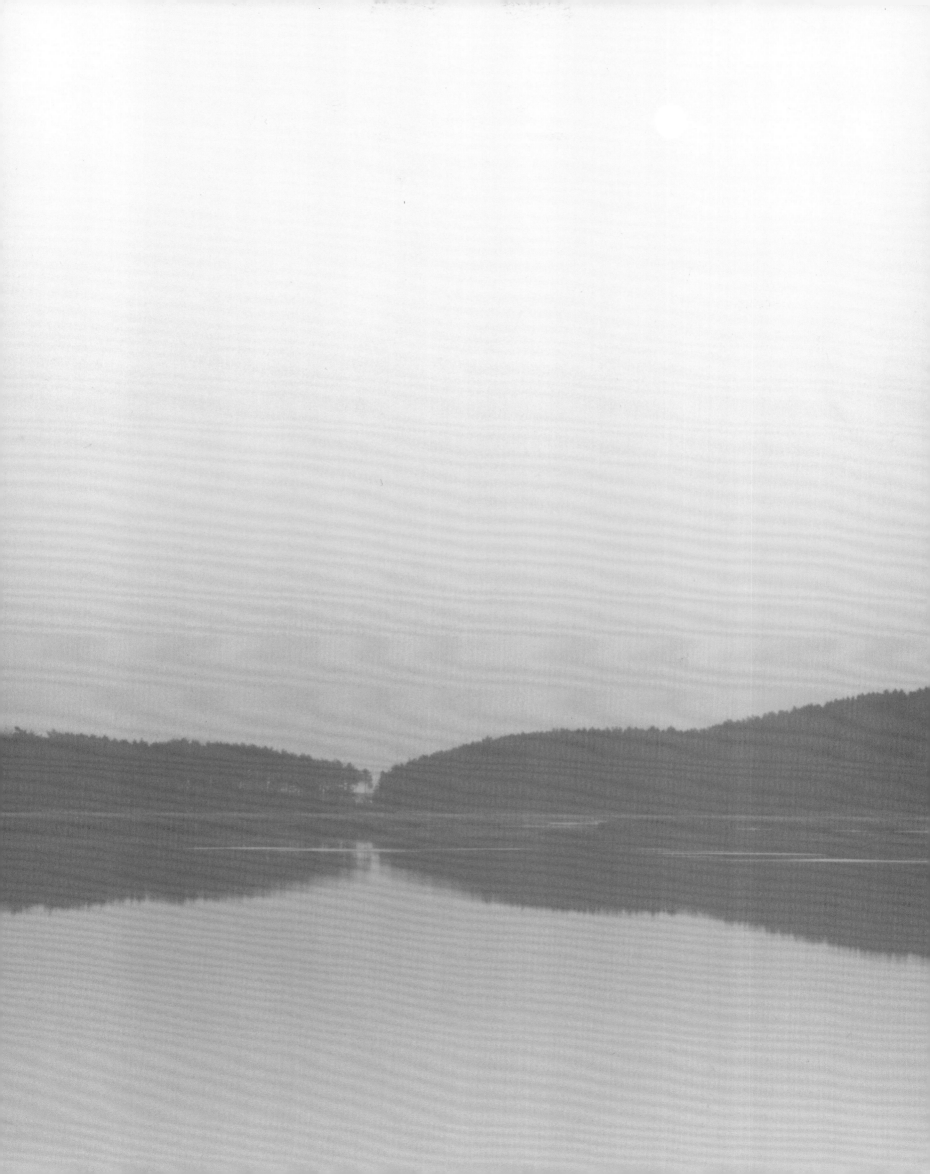

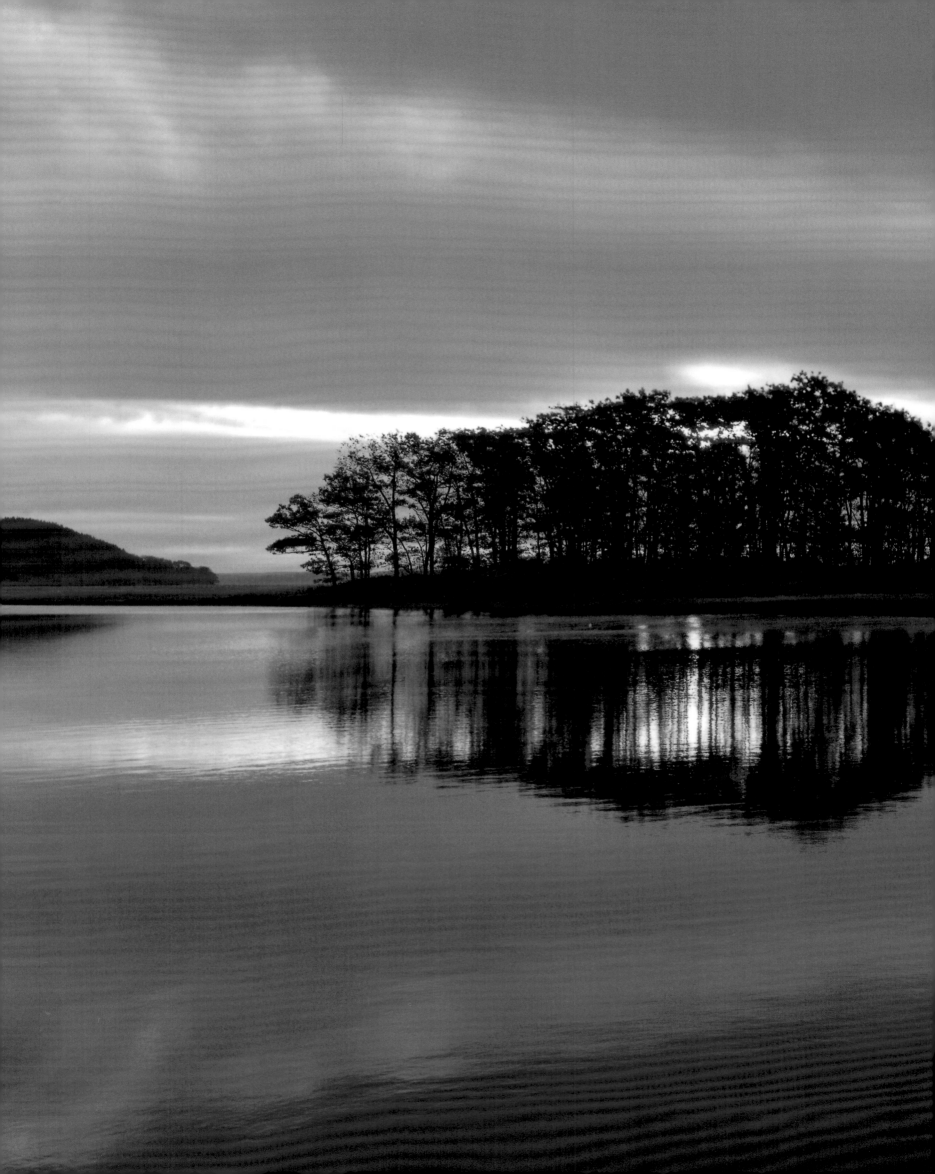

Between Land and Sea
THE GREAT MARSH

PHOTOGRAPHY BY **DOROTHY KERPER MONNELLY**

FOREWORD BY **JEANNE FALK ADAMS**
ESSAY BY **DOUG STEWART**

GEORGE BRAZILLER

To the Great Marsh
and other natural landscapes around the world, as they hold the truth
for us and, I hope, for generations to come.

Library of Congress Control Number: 2006929321
ISBN-10: 0-8076-1578-1
ISBN-13: 978-0-8076-1578-2

Editorial and art direction by Barbara Cox
Designed by John Hubbard
Copyedited by Judy McNally
Produced by Marquand Books, Inc., Seattle
www.marquand.com
Printed and bound in China

All photographs were taken in the Great Marsh and connecting
wetlands of Essex County, Massachusetts.

Half-title page: **Long and Hog Islands, Moonrise**, Ipswich, October
Title page: **Witch Island, Daybreak**, Ipswich, November
Pages 4–5: **Sand Pattern #7, Reconciliation Series**, Crane Beach, Ipswich, September
Page 10: **Nut Island, Salt Marsh Grasses**, Ipswich, September
Page 20: **Sand Pattern #3**, Crane Beach, Ipswich, November
Pages 26–27: **Salt Marsh Island, Clouds**, Ipswich, May
Page 110: **Sand Pattern #9, Reconciliation Series**, Ipswich, September

CONTENTS

FOREWORD

My English ancestors arrived in Newbury/Newburyport, Massachusetts colony, in 1637, and later settled in Ipswich, which is now defined as part of the Great Marsh at the Atlantic Ocean in Massachusetts. Although I have lived in California all my life, the first time I set foot in Massachusetts, I immediately felt at home, as if reconnecting with my ancestors.

When I discovered Dorothy Kerper Monnelly's compelling photographs, my sense of place and intense interest in her bioregion and landscape rekindled my own sense of place and intense interest in landscapes my family knew. Monnelly finds *home* in that landscape, and her passionate commitment persuades me that I could, too. Her art is more than just beautiful black and white photographs. It triggers something, moves me to care, to learn more about the area, and to appreciate my own environment with greater connection. It is telling that Monnelly is fond of quoting from Robert Frost's poem "The Gift Outright." The philosophy behind her photography is embodied in his suggestion that the land isn't ours until we give ourselves to it. This surrender, so central to Monnelly's sense of place, starts a flow that continues to enrich her connection with the landscape.

> *Something we were withholding made us weak*
> *Until we found out that it was ourselves*
> *We were withholding from our land of living,*
> *And forthwith found salvation in surrender.*

Monnelly's images provoke a call to action. Her work stems from a deep belief that pictures must communicate to the public some essential value, perhaps an appreciation of our last great places. Her photographs capture the salt marsh islands and drumlins and their amazing sculptural quality. The first time I looked at these images I wondered, what is it about this place that prompted her to spend so many years making these photographs?

As a student in Boston, Dorothy Kerper discovered Ipswich and the nearby wild barrier beaches, drumlins, and salt marshes now known as the Crane Reservation, on the Massachusetts North Shore. The Trustees of Reservations had wisely stewarded and protected that rich ecosystem and fragment of natural landscape, with a hope of providing respite for urban dwellers. For the last thirty years, Monnelly has been drawn to this refuge and worked to help others feel a vital connection with the natural landscape.

With her husband and children, Monnelly has thrived in her sanctuary, living simply next to a beautiful pond in the marshland. Recently she told me, "My feeling in the landscape is in the forefront of my work, with the visual woven in almost unconsciously. A sense of place is a frame of mind; it is a matter of focus."

One sees in her photographs the power of serenity, sense of reverence, and innocence of place, along with the interplay of light. Monnelly is artist, mother and wife, "cultural creative," environmental advocate and educator. Her life is defined by the landscape she so loves and also by the photography that informs her being. As Wallace Stegner says, we need to be quiet part of the time and to acquire not the sense of ownership, but of belonging.

For me, Monnelly does just that. She also embodies a model of what I consider a *new indigenous* woman, leading a simple and authentic life that we need for our time—in the tradition of Rachel Carson and Gary Snyder. She reads the sea. Her photographs speak a language that says, "Look, slow down and look, and see in a very personal way."

My own frame of reference is the large Western landscape, federally protected in the 1890s, when natural areas of the developed industrial Atlantic Coast were largely ignored. The privately protected 20,000-plus acres in seventy miles of Great Marsh (from Cape Ann to New Hampshire) attest to the consciousness of value of the marshlands for their biotic function as kidneys and lungs, open space, and habitat of fish and shore-birds, and as a major migratory stop. It is the largest contiguous acreage of salt marsh in New England. In addition to its extraordinary power and beauty as a landscape, the salt marsh—composed of salt marsh grasslands, barrier beach, tidal creeks, mudflats, estuaries, and upland islands—is one of the richest ecosystems on earth. But this vital sanctuary is under siege. Centuries of human contact have depleted some clamming areas. Urban contaminants degrade the marsh. Intrusion of invasive reeds could destroy it. A rising sea level can flood and drown it. The need for vigilance and significant mitigation is great.

Fortunately, the Massachusetts Wetlands Restoration Program is in progress. Monnelly actively and quietly participates in a number of efforts to help sustain the ecosystem, including work with the Ipswich Open Space Committee to identify and protect important open space in the town. Devoted to this extraordinary landscape, Monnelly shares in the experience of the elements—tides, wind, light, storm, and calm. A third-generation Ipswich native (who is manager of the Appleton Farm, a Trustees of Reservations property) told me that those who come to Ipswich and participate in the life of the marsh stay. Those who don't, leave. The more Monnelly travels in the world, the more she feels the embrace of home. Residents try to live respectfully with the landscape, in the hope that it will continue to function naturally.

In a sense, as one of the correctives to adverse pressures, Monnelly's contribution as an artist is equivalent to that of the scientists who work to sustain and restore the landscape. By creating these images, she opens for the viewer a way of seeing—a vision of what is and what needs to be that is elegant in and of itself. She has carved out a unique niche for herself, what might be called "ethical landscape photography." And she has done this in what is typically the domain of male photographers, large-format

black and white photography. Working in large-format photography is a deliberative process, including making exposures in the field and photographs in the darkroom. "It is through the process of photographing in the landscape that I stay in touch with who I am," Monnelly says.

For Monnelly, photography is the biggest thing one can say without words. I envision her quietly slipping out of her home well before dawn, driving down a neighbor's lane toward the marsh, gathering her equipment to set off on foot, taking extreme care in the dark in navigating the ditches, keeping her hands warm enough to function, having the technique down pat so that her attention can go to the visual, setting up in a preselected site, as she awaits the first light of day to silhouette the oaks in the distance. To achieve an understanding and a visceral connection with place, we learn about it, participate on nature's terms over an extended period, and come to feel that trust, belonging, and caring. As a photographer, Monnelly has a rare sense and perception of what I think of as the *thoroughness of place,* knowing the Great Marsh and its nuances intimately, much as did Ansel Adams the Sierra Nevada and his beloved Yosemite National Park.

Does Monnelly's artistic expression—her interpretation of the Great Marsh and statement of hope—succeed? For me it does. I find myself responding emotionally and know the photographs touched me. Today, with the fine technology of cameras, it is possible to make a good photograph accidentally. However, there is a difference between being clever and being great. This body of work transcends technique by asking us to care, to slow down, to connect with place, to look again more deeply. In the best of her work she helps us to see, inspires us, and encourages us to find joy in our own environment—the special place for which we care. In a time of perpetual rushing and overprogramming, it is more difficult to slow down, pay close attention, feel, and participate as stewards. These photographs of the Great Marsh gently invite us to do so. The choice is ours.

––––––––––––––––––––––––––––––

Jeanne Falk Adams

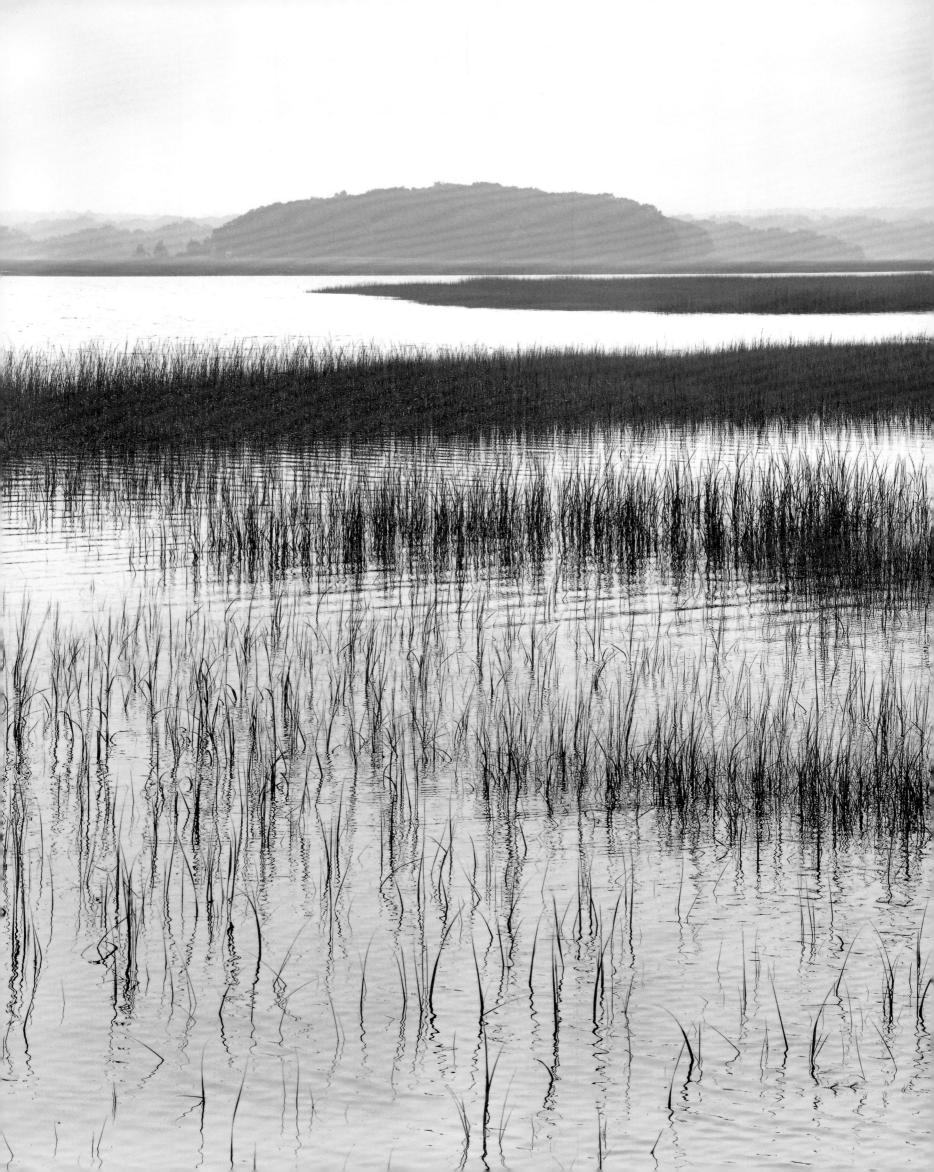

OF TIDES, MUD, AND MARSHES

DOUG STEWART

To stand at the edge of the sea, to sense the ebb and flow of the tides, to feel the breath of a mist moving over a great salt marsh, to watch the flight of shore birds that have swept up and down the surf lines of the continents for untold thousands of years . . . is to have knowledge of things that are as nearly eternal as any earthly life can be.

—Rachel Carson

Could any landscape be as timeless as the vast prairie of a salt marsh? Even the Grand Canyon is eroding, after all, but a healthy coastal marsh is renewed with each rising tide.

Or so it seems. In fact, a salt marsh depends for its survival on a finely tuned balance of fresh and salt water. Too much of one, and it turns into a brackish, shrub-dotted swamp. Too much of the other, and it drops into the sea. As people crowd the shorelines of the world's continents, that delicate arrangement is being thrown out of whack.

Salt marshes are found on both coasts of North and South America, in Europe, the Persian Gulf, South Africa, Japan, Australia, and Siberia. Being flat and accessible and usually above sea level, marshes have seemed like virgin real estate to human settlers for centuries. Many of the world's great cities were built largely on salt marsh, including Boston, Philadelphia,

Amsterdam, and Buenos Aires. The Grand Canal in Venice is still recognizably a tidal channel winding through a marsh.

Like wetlands generally, salt marshes in many places are shrinking—usually, directly or indirectly, as a result of human activity. People who lack a connection to them may count this a good thing. Marshes are often dismissed as vaguely malevolent wastelands, muddy, smelly, and bug-infested, suitable only for draining or filling. Their sheer emptiness can be forbidding. Novelist Paul Gallico wrote in *The Snow Goose* (1940) of a salt marsh in the Thames estuary not far from London: "It is desolate, utterly lonely." Perhaps that characterization reveals more about the writer, however, than about the marsh. How you respond to a salt marsh depends on your mood, the weather, the time of day, the point of tide, the marsh's history and your own.

For those with the patience to experience its rhythms and subtle beauties, a salt marsh is both bracing and peaceful, spectacular and placid, mysterious and majestic. And primeval: a salt marsh is a glimpse into prehistory, for it's one of the few parts of the coastal world that look much as they did tens of thousands of years ago, before human settlement.

A salt marsh is unique terrain. It's not sea, yet it isn't quite land. It's something in between, a netherland. Viewed from high ground on a stormy fall day, the Great Marsh in northeastern Massachusetts is one moment a parched-looking, windswept plain stretching to the horizon with only a tiny duck-hunting shack punctuating the distant flatness. The vista seems infinite, more what you'd expect of Nebraska than of a locale just north of Boston. A few hours later, if there is a spring tide (a twice-a-month occurrence), you'd think a catastrophe had arrived: the landscape is inundated, perhaps even topped with whitecaps and streaks of salt spray. The watery expanse is broken only by a few forested islands in the distance. Closer by, hedgerows of cordgrass barely perforate the

surface of this ocean that has somehow materialized as if by magic—and will soon vanish just as magically.

The drama, the immensity—the sheer sneakiness—of a spring tide flooding a marsh is always a surprise. At twilight with a full moon rising, you glance out a window at what you're accustomed to thinking of as terra firma and are startled to see a trail of silver rippling toward the horizon. Under cover of darkness, the sea has crept in over the marsh.

Grasses that thrive under regular pickling in seawater are obviously well-adapted to what for other plants would be certain death. Relatively few are up to the task. This explains the unbroken sweep of a healthy salt marsh: large swaths of it are dominated by a single species. On the New England coast, the low marsh, flooded at least half the time, is covered in smooth cordgrass, *Spartina alterniflora*. Anchored by a formidable network of roots, this sturdy grass can reach a height of ten feet. Slightly higher ground, which floods only occasionally, is blanketed in the more delicate salt-meadow cordgrass, or salt hay (*Spartina patens*), which can form matted spirals and tufts in the fall. At a marsh's upland edge—drier and less salty still—salt-marsh elder and black grass dominate.

The Great Marsh in Massachusetts, one of the most pristine salt marshes in North America, extends along the coast of Essex County from Cape Ann to the New Hampshire border. It is the largest intact salt-marsh ecosystem north of Long Island. The Great Marsh includes more than 20,000 acres of largely undisturbed salt marsh, mudflats, estuaries, barrier beaches, and marsh islands. Most of it is now protected as conservation land. In the flats along the tidal creeks and rivers, clamming remains a major commercial activity year-round; on the uplands, a few farmers still harvest salt hay each fall. The Great Marsh's primordial beauty is an apt backdrop to the hodgepodge of colonial saltbox houses sprinkled throughout the small towns of Essex, Ipswich, Rowley, and Newbury that border the marsh.

Landscape aesthetics is only one reason to treasure a healthy salt marsh. Biologically, marshes are the sun-fueled engine powering one of the most productive ecosystems on earth. A single acre can produce ten tons of organic matter in a year. By contrast, an acre of well-managed wheat field, laboriously cultivated and fertilized, yields a ton and a half. The nutrients that marsh plants make available form the base of an astonishingly diverse food chain, from protozoa to mammals (including shellfish-loving humans).

Indeed, salt marshes provide sanctuary for an ark's worth of wildlife. Tidal grasslands attract migrating waterfowl, shorebirds, and songbirds. Bitterns, or marsh herons, are so well adapted to marsh life, they disguise themselves when startled by pointing their bills skyward, impersonating stalks of cordgrass. Fiddler crabs scuttle among the grasses, scraping the mud for algae, while mummichogs and sticklebacks dart up and down the mud-walled creeks and channels, seeking both food and refuge from predators. After the tide goes out, minnows and other small fish stay behind in the shallow pools, or salt pans, that dot the carpet of grasses. Many of the nutrients a marsh produces aren't consumed locally but are flushed out by the tide to the continental shelves, where commercial fisheries around the world depend on them.

Just as plants and wildlife need to be adapted to salt-marsh life, so humans living in marshy terrain have to adapt themselves to a world that's half land, half water. The mazelike reversing channels that wind through the shoals and grass islands of a tidal estuary are a nightmare for boaters unfamiliar with them. In Erskine Childers' classic 1903 spy novel, *The Riddle of the Sands*, the confusion of sailing the narrow, uncharted inlets of Germany's North Sea marshes is central to the plot. Even with a detailed chart, canoers and kayakers today who cheerfully paddle up a narrowing marsh creek on an ebb tide may soon find themselves aground and slapping mosquitoes.

A New England marsh's subtle colors reward the patient observer, especially one willing to pull on boots and explore on foot. Sprays of salt-tolerant sea lavender, or marsh rosemary, reveal tiny purple-tinged blossoms along their branching stalks. On higher ground, black grass bordering the marsh is actually a rush related to the lily; its flowers are miniature lily blossoms. Thick-stemmed samphire, or glasswort, grows here and there in dense, ground-hugging forests; its scalelike leaves turn patches of marsh a flame-red in early fall. Even the dominant cordgrass, up close, reveals tiny purple flowers along its stalks.

Harder to miss are the dramatic shifts in a marsh's character as the seasons pass. In spring, starting along the tidal channels, the grasses gradually shift from a muddy, monochromatic gray-brown to a softer, luminous green as energetic new shoots of spartina begin to upstage last year's brittle stalks. In late summer, the marsh is a radiant, windblown gold, as uniformly lush as a field of summer wheat. By year's end, the marsh turns somber and austere once again as the spartina dries up and dies back.

Even during a long New England winter, when the Great Marsh is as bleak as tundra, the surging tides animate the landscape. In cold spells, day and night, tidewater lifts the thick, brackish ice covering the channels, only to drop it again as the water underneath rushes back out to sea. As the ice sheet falls, it pounds the frozen mud bluffs along the sides of the waterways in imperceptibly slow motion. Massive shards of ice pile up in curving jumbles of debris, as though an earthquake had buckled the earth along an oddly winding fault line. A few hours later, the swelling tide has once again stitched the rubble into a seamless plateau of white.

A marsh comes into being when fine-grained sediments swept in by rivers or tides settle in protected shallows—either behind barrier islands or

along the shores of tidal estuaries. Seeds sprout in the sediment. As plants take root and spread, the scouring action of waves and tides slows, and still more sediment settles. (The stickiness of a salt marsh's fine-grained mud is unrivaled, as anyone who's explored one at low tide can attest. On the flats, it sucks the boots and socks off your feet unless you keep up a brisk, light-footed gait.) Dense tangles of roots bind the mud and dead grasses, forming a thick, muddy thatch that eventually turns to peat. Year by year, the peat thickens; the ground rises. What was once barren mud becomes a dense, grassy expanse that only the highest tides now reach.

Like coral atolls that stay just above the ocean's surface by growing new layers at the same rate that the ground beneath them sinks, a salt marsh is capable of colonizing new ground as sea levels rise (within reason). The salt marshes of maritime Canada and New England did just that as the massive Laurentide Glacier melted at the end of the last Ice Age, some ten thousand years ago. Sea levels rose dozens of feet, and so did the salt marshes. As seawater invaded coastal lowlands, killing the freshwater plants, the marsh grasses took over. When highway engineers several decades ago were building a new highway through a marsh near Hackensack, New Jersey, they discovered the toppled trunks of giant cedars ten feet underground: thousands of years ago, the land was a freshwater cedar bog. As the sea level rose, encroaching seawater killed the trees, and the bog turned to marsh. (One of the curiosities of a salt marsh is that so much of the dead vegetation piles up in peaty layers, rather than rotting away completely. The waterlogged soil contains so little air that fungi and bacteria underground have trouble composting everything.)

Freshwater from upstream is as vital to a marsh as seawater from offshore. Water is an almost universal solvent, and as it flows in rivers and streams toward a coast, it carries not only sediments but also dissolved nutrients from soil and rotting vegetation. Adding to the mix, rapids saturate the water with oxygen. In ponds along the way, dead leaves leach out

their nutrients as insects and microbes consume them, even under sheets of midwinter ice. The resulting organic broth, though highly dilute, is a key to the abundance of life downstream.

To the Native Americans who lived in coastal New England before the first Europeans arrived, the salt marshes were a cornucopia of fish, shellfish, and wild game. The dunes and drumlins of the Great Marsh today are littered with traces of their activity in summers long ago: heaps of ancient clam and oyster shells along with arrowheads and the bones of the animals they killed nearby—duck, turkey, deer, bear, seal, and the occasional great auk.

The vastness of the New World's coastal marshes astonished early European visitors. Adriaen Van Der Donck, a Dutchman who sailed into the Hudson River estuary in 1642, marveled at the "brooklands and fresh and salt meadows, some so extensive that the eye cannot oversee the same." Not every settler welcomed the sight of so much wet terrain. Captain John Smith of Pocahontas fame felt it necessary to report to English readers of his *Generall Historie* in 1624 that he had seen no large "unwholsome Marshes" in Virginia. The wetlands he did see he judged "more profitable than hurtfull."

The coastal marshes proved to be valuable indeed, not only for the wildlife they harbored but for the marsh grass itself. Most of the uplands along the East Coast were heavily forested in colonial times, and clearing land for grazing was a slow and arduous task. Moreover, as the early settlers discovered, native dry-land grasses quickly succumbed to regular grazing by livestock. To keep their animals from starvation, the settlers soon began herding them onto the marshes to graze on salt hay. The hay needed neither seeding nor fertilizing, thanks to the tides. Small wonder so many of our oldest towns are situated on tidal marshes.

On the Great Marsh in Massachusetts, the harvesting of salt-meadow grass was a popular communal activity until the turn of the twentieth

century. In the fortnight interval between spring tides in August or September, scythers would be visible across the marsh in all directions. Men and boys piled the hay on circular platforms, called staddles, that were just high enough to stay above the highest tides. The workers rowed or poled the dried hay up the creeks on narrow barges called gundalows (a local corruption of "gondola"). The hay was used by farmers not only as fodder but also as thatch for cottage roofs, as bedding for livestock, and as insulation around house foundations to keep out winter drafts.

By the early twentieth century, with farming on the decline in coastal New England, demand for salt hay dropped. Owning a parcel of salt marsh was no longer desirable. Marshes were too wet to build on, too dry to navigate, too salty to drink from, too empty to admire. In a misguided attempt to drain them, largely for mosquito control, communities during the Great Depression put unemployed laborers to work gouging ditches into the low marshes. From 1931 to 1933, more than a thousand miles of ditches were scraped into the Great Marsh alone. Unfortunately, the effort was more successful at providing paychecks than eradicating mosquitoes.

In Hampton, New Hampshire, where a sandy barrier island had become overcrowded with summer cottages by the 1920s, civic leaders laid plans to fill in much of the salt marsh alongside it. The 1,800-acre marsh—adjoining Massachusetts' Great Marsh—was to become the site of more than a thousand new homes with tree-lined boulevards and an international airport. Later plans called for simply obliterating much of the wetlands with landfill and putting a 10,000-car parking lot on top.

Hampton's voters eventually decided they preferred salt marsh to parking lots, but in more populous stretches of both U.S. coasts in the 1950s, 1960s, and early 1970s, marsh-filling grew to something of a national mania—an aquatic version of slum clearance. Salt marshes were filled in and paved over to make room for subdivisions, factories, farms,

shopping centers, and sewage plants. They were dredged for sand and gravel, scooped out to make room for pleasure boats and oil tankers, and carved up by highways and railroad tracks. Up and down the East Coast, a succession of new airports and sports stadiums were sited on salt marshes. It all seemed like a good idea at the time. When an oil company in the 1960s built a new refinery in record time on what had been sixty-five acres of salt marsh, it made no apologies. In fact, the company made a television commercial boasting of its achievement.

Over the past century, coastal states as a whole lost more than half their shoreside wetlands. In Puget Sound, barely a quarter of the original salt marsh survives today. Galveston Bay has one-sixth of its original salt marsh left; San Francisco Bay, a twentieth. Environmental regulations in recent decades have put an end to rampant salt-marsh destruction. Still, marshes continue to suffer unintentional damage. More than half the population of the United States now lives or works in coastal counties. Inevitably, human activity affects the flow and quality of water entering a marsh. Because marsh grasses are adapted to such a narrow ecological niche, they're vulnerable to disturbance. One of the innocent-seeming byproducts of coastal development is nutrient-rich freshwater, which leaches from chemically treated lawns and farms, waste-water treatment plants, failing septic tanks, and the like. Another culprit is storm water runoff, which washes oils and other pollutants from roadways into water-ways. If too many pollutants seep into a salt marsh, the grasses begin to die. Cattails, bulrushes, and, increasingly, a plume-topped alien reed called phragmites invade the high marsh.

Momentum today is firmly on the side of salt-marsh preservation. Environmental groups on both coasts and along the Gulf of Mexico have restored hundreds of damaged marshes, for example, by reviving tidal flow where roads and embankments had blocked it. The Great Marsh, healthier than most, is still vulnerable to development at its edges. A number

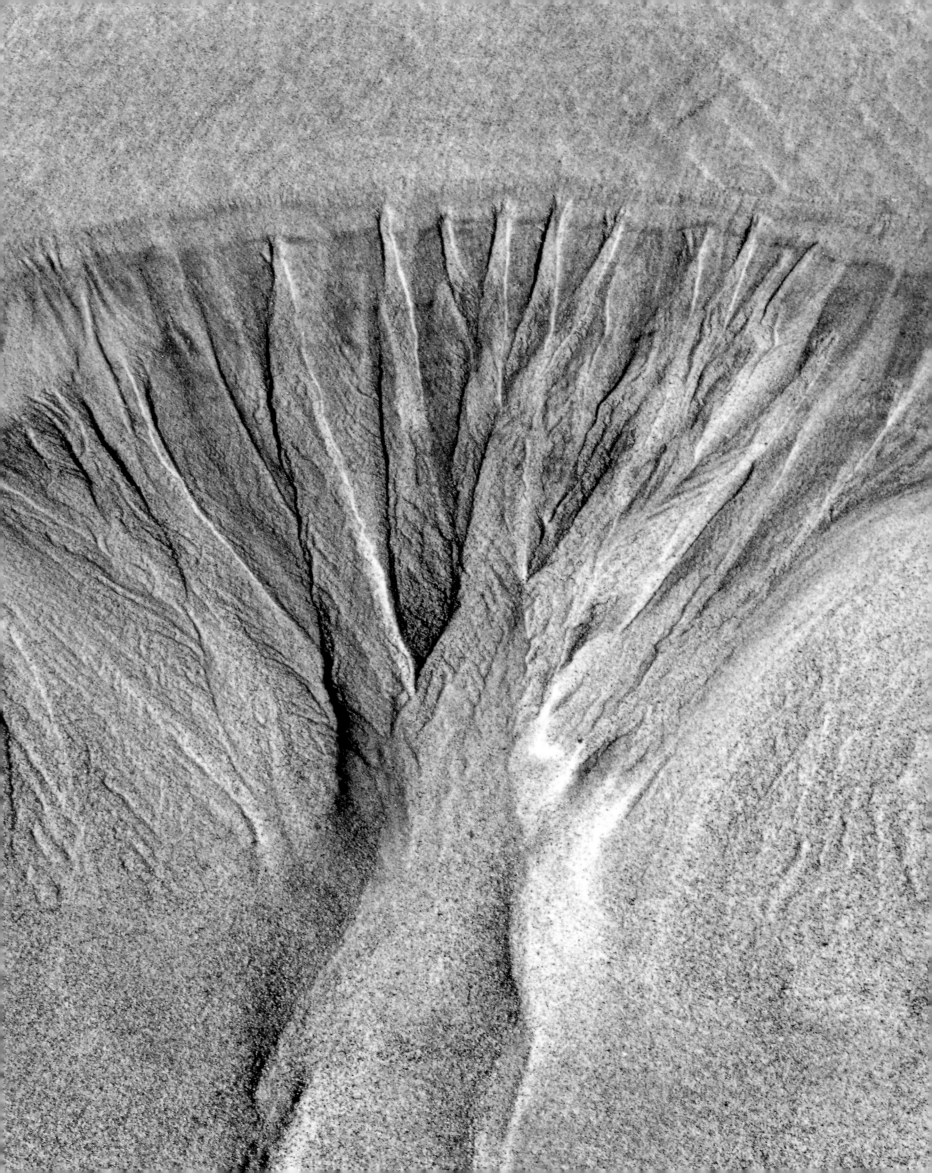

of groups—from state and federal agencies to town conservation boards and local environmental advocates—have banded together to protect the marsh from pollution and encroachment. For them, as for any salt-marsh champions, the most fundamental task is to educate the public about why these wetlands are valuable and how they can stay that way.

The essential fragility of salt marshes is obvious in a view from space, where they appear as a broken, barely noticeable fringe at the edges of continents. Skirting the marshes to seaward is a lighter, even narrower outline. These are the fragile necklaces of barrier islands that shelter salt marshes from ocean waves and storm surges.

Without barrier beaches, most salt marshes on the Atlantic coast wouldn't exist. Beaches protect the low-lying salt marshes behind them from battering by ocean waves, especially during storms. A barrier beach in its natural state grows and decays over time, its fate determined by water and wind. Every day, 8,000 to 12,000 waves sweep up onto a beach, leaving a filigree of swashes, cusps, rills, domes, steps, backwash diamonds, and ripples of infinite variety. In doing so, each fair-weather wave lays down a minute new layer of sand on the millions of layers already in place. Storm waves drag more sand back into the water in their foaming backwash than they deposited moments before.

Wind has its own way of transporting sand. In winds above thirty miles an hour, grains of sand are picked up and carried short distances. On landing, they dislodge other grains, which become airborne in turn. At these times, the air within a few inches of the beach seems to be an abrasive, sand-blasting haze of horizontal motion. Dunes grow as windblown sand particles slide up the beach and drop off the steep back side. Over time, they migrate and shape-shift. An old wooden shipwreck can be

covered by a growing dune and lie forgotten for most of a century, then wind and waves push the dune a dozen yards inland, and the wreck is news all over again.

On Castle Neck in Ipswich, high dunes have slowly buried groves of mature pitch pines and birches. In 1892, Ipswich dune-and-marsh connoisseur Charles Wendell Townsend photographed an apple orchard on the marsh side of the barrier peninsula. (Castle Neck is actually a set of sand-covered drumlins, or mounds of glacial till, scraped up during the last Ice Age. What appears to be sand dunes today was farmland in the nineteenth century.) Twenty years later, Townsend discovered, nearly all the apple trees had disappeared under the advancing sands. Oddly enough, full-grown trees don't necessarily die of asphyxiation as they're buried; in many cases, their roots keep growing in the soil deep beneath the sand, and the unburied topmost branches continue to put out foliage.

Most dune vegetation is more specifically adapted to life amid shifting sand. Beach grass, in fact, won't grow at all in sand that doesn't move. Only when the plant senses that windblown sand has piled up around its stalks does it send out new roots, which propagate fresh shoots. The roots of another dune plant, marram grass, can penetrate ten to twelve feet underground, deep enough to reach water from atop a sizable dune. The flora of the barrier beach, like plants in the desert, tend to be small and waxy, the better to resist evaporation. Bayberries, native to this terrain, contain so much wax that people in centuries past boiled them to make candles.

Although roots help bind a dune in place, severe storms can quickly collapse even a massive dune, roots and all. When dunes erode in storms, the sand normally doesn't travel far; it may move to a sandbar offshore. By and large, the beach's protective role isn't compromised. When people build on beaches, however, they try to force the dunes to stay put, which no dune ever does. Beach-front development brings with it jetties,

seawalls, and other structures that redirect the way sand moves, often in unpredictable ways. As a result, built-up barrier beaches are losing sand and suffering breaches. Behind them, the salt marshes are at risk.

More worrisome still, all barrier beaches are vulnerable to rising sea levels, which global warming is poised to accelerate. When the Ice Age glaciers melted and the seas rose, the marshes were able to keep up. If we allow the rate of sea-level rise to climb in the coming century, our beaches and marshes will suffer. Those infinite layers of sand assembled by waves over the millennia into mighty barrier islands are, after all, just grains of sand. We shouldn't mistake them for impenetrable seawalls.

No place is a place until it has had a poet.
—Wallace Stegner, "The Sense of Place"

For artists who take their inspiration from the natural world, perhaps their most important role is fixing a concentrated attention on hidden things the rest of us can't see or plain things we overlook. Fragile and mysterious, salt marshes have for centuries been ignored if not disdained. "As scenic features, they are monotonous and uninteresting in the extreme because of their lack of relief and uniformity," wrote a geologist a century ago (veering somewhat outside his field of expertise). It's true that a salt marsh—compared to, say, a river valley—has never been a common subject for artists, largely because capturing its invigorating sweep is so difficult. There have always been those, however, who have seen beyond the flatness and the mud, the stark topography and limited palette.

One of the first major landscape artists drawn to marshes was the American luminist Martin Johnson Heade. In the 1860s and 1870s, he

produced more than a hundred oil paintings of Northeastern marshes and especially the Great Marsh. Heade favored sunlit salt-hay meadows under storm clouds, with distant wagons, contented livestock, industrious farm-workers, and haystacks receding toward the horizon. He understood the marsh's ambiguous status as neither land nor sea: his views have the panoramic wildness of a seascape, yet at the same time are as comfortably terrestrial as an apple orchard. Heade usually painted the marsh when the tide was in, so the brimming creeks resembled wilderness streams invading an agricultural Utopia.

Several decades later, Ipswich painter Arthur Wesley Dow also drew inspiration from Essex County's salt marshes. For the Japanese-influenced artist, the marsh was a rich source of modern, asymmetrical compositions and unusual colors. He and his friend, photographer Alvin Langdon Coburn, were particularly taken with the view from Dow's hilltop studio of a serpentine tidal channel in the distance. Both cryptically titled their views "The Dragon," as though a sea monster from the Orient had quietly materialized at the outskirts of a New England village.

Admirers of salt marshes have usually been people who have spent their lives near them, not visitors scouting for scenic views. In 1848, the Massachusetts romantic poet and critic James Russell Lowell chided the common marsh-phobe in "An Indian-Summer Reverie":

> *Dear marshes! vain to him the gift of sight . . .*
> *Who sees in them but levels brown and bare;*
> *Each change of storm or sunshine scatters free*
> *On them its largess of variety,*
> *For Nature with cheap means still works her wonders rare.*

―――――――――――――――――――――――

The camera work of Ipswich's Dorothy Kerper Monnelly is eloquent testimony to the marsh's rare wonders. Her attachment to the unique geography of the marshes and estuaries of Essex County comes from more than thirty years of explorations with camera in hand. "The marsh is my home landscape," Monnelly says. "To me, it's a place of splendor."

In formal terms, Monnelly is drawn to the unditched marsh's stripped-down sculptural qualities: the uniform planes of grass and water, the creeks and salt pans reflecting softly rounded drumlins fringed with oaks, the sharp slash of an unbroken horizon anchoring an immense, unimpeded sky. Her works are studied compositions; transient elements like people and shorebirds would be out of place.

But these are not cerebral constructions. Monnelly's photographic compulsion arises from a strong emotional bond to this landscape and the community around it. "This is where I live with my family," she says. "This is where I raised my children. I sing here. I swim in the marsh. The boats in my photographs belong to my friends. I have a tender feeling about my little community—the town meetings, the gardens, the music, the friendships. There are layers to my awareness and appreciation for this landscape now. For me, the layering enriches everything."

The salt marsh that inspires her has been putting down gnarled roots for thousands of years. That thickening weave is no guarantee that the marsh will be here in another thousand years. Monnelly hopes the quiet intensity of her images will prompt people to look anew at a part of the world that has long been misused and misunderstood. "I'm not an ecologist," she says. "Photography is my strongest voice. It's the best way for me to advocate for this landscape."

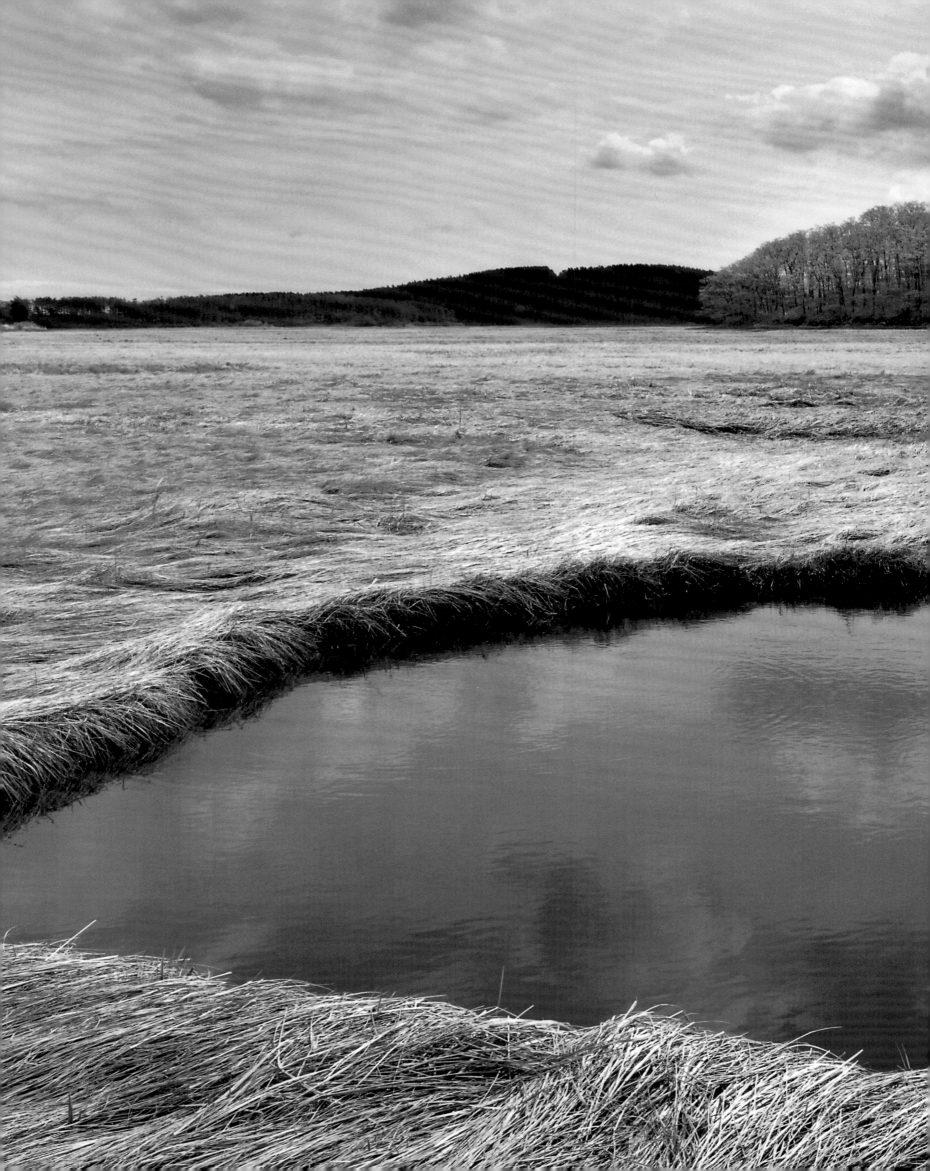

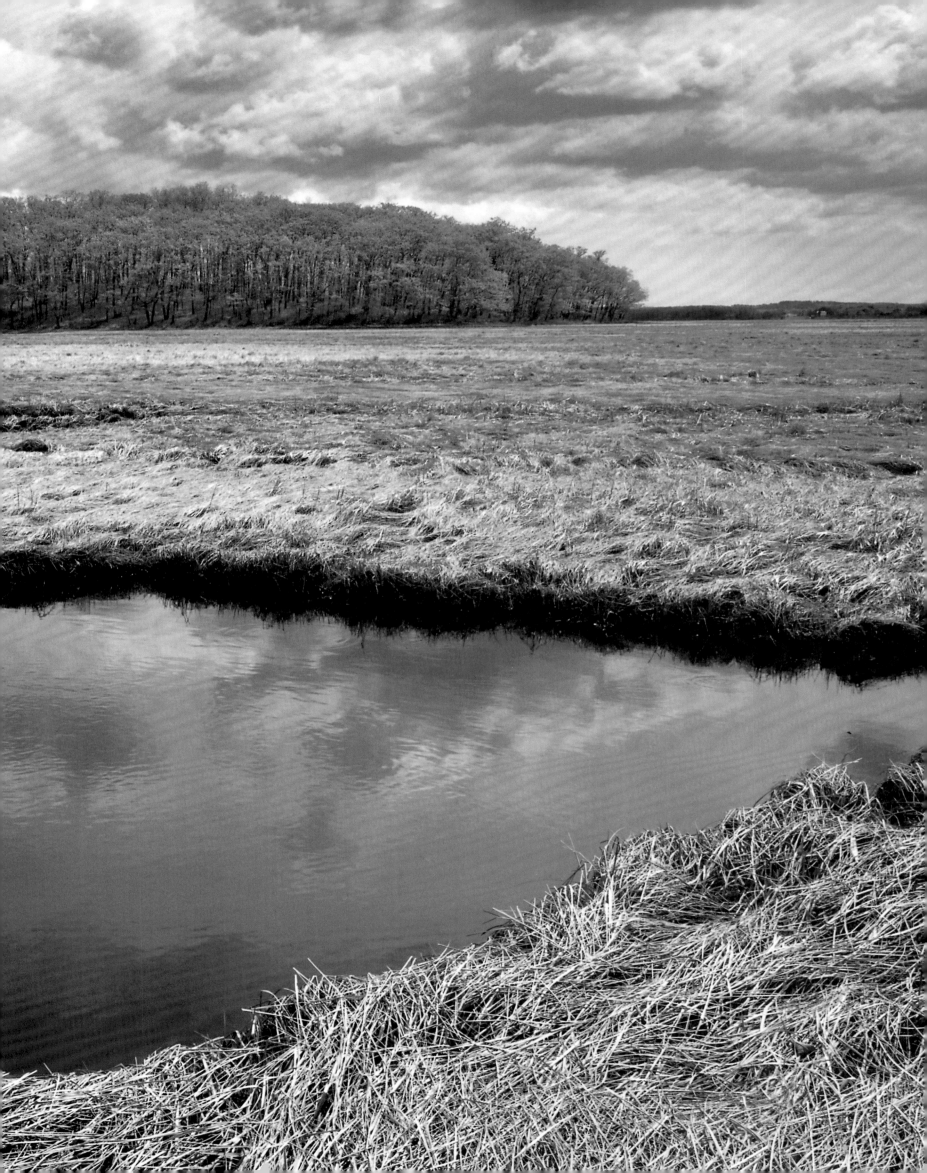

Expanding Cloud, **Predawn**, Ipswich, November

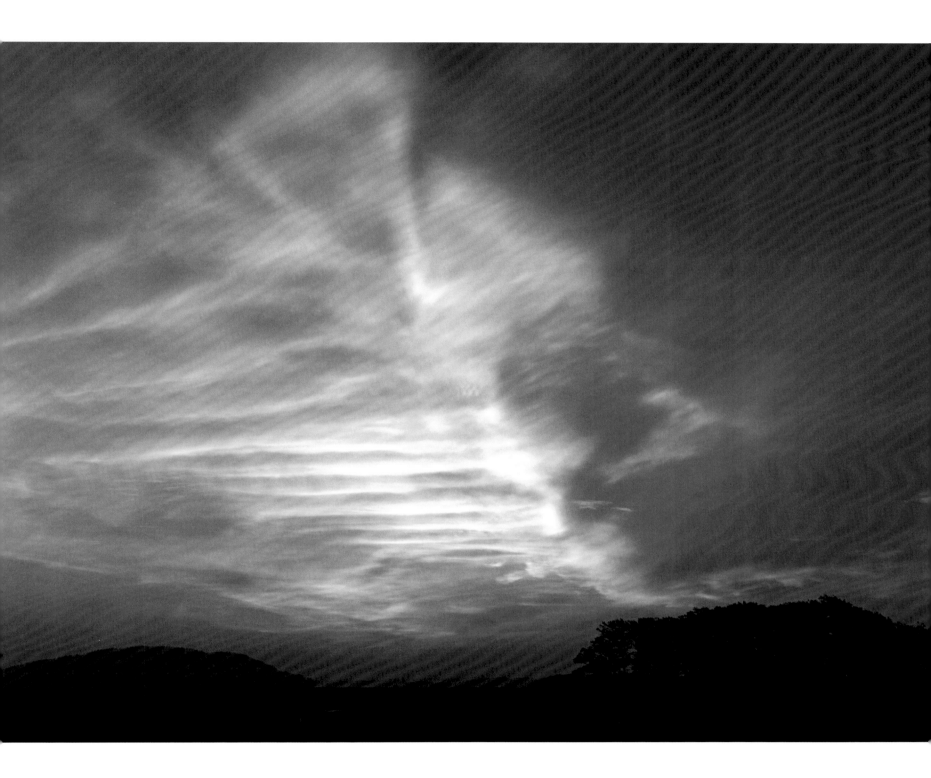

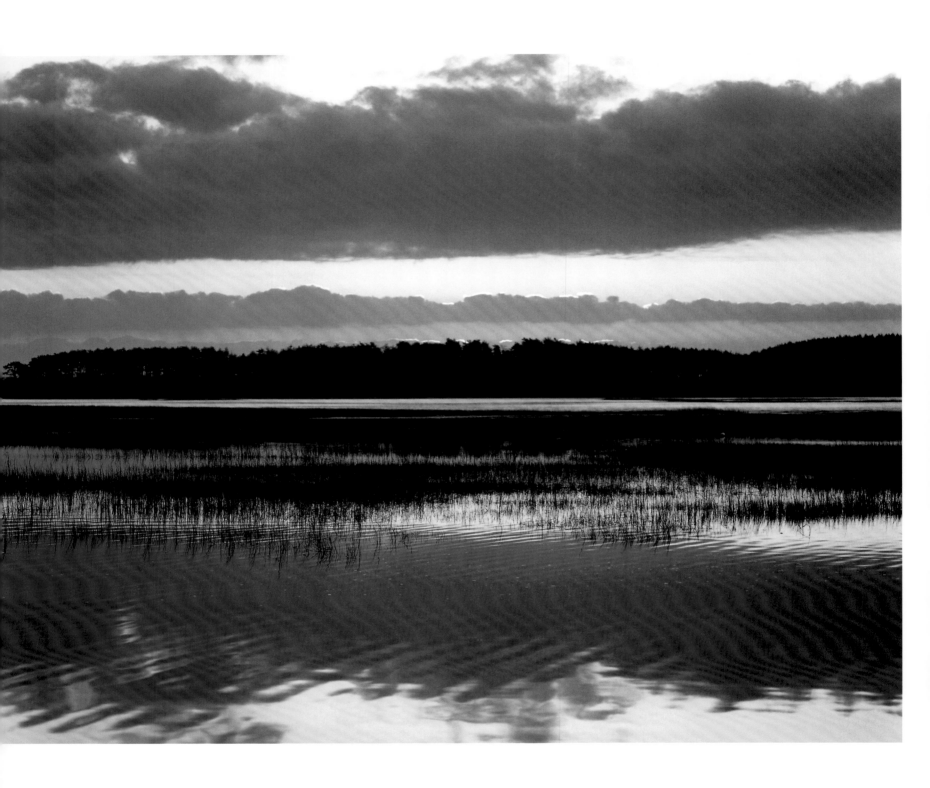

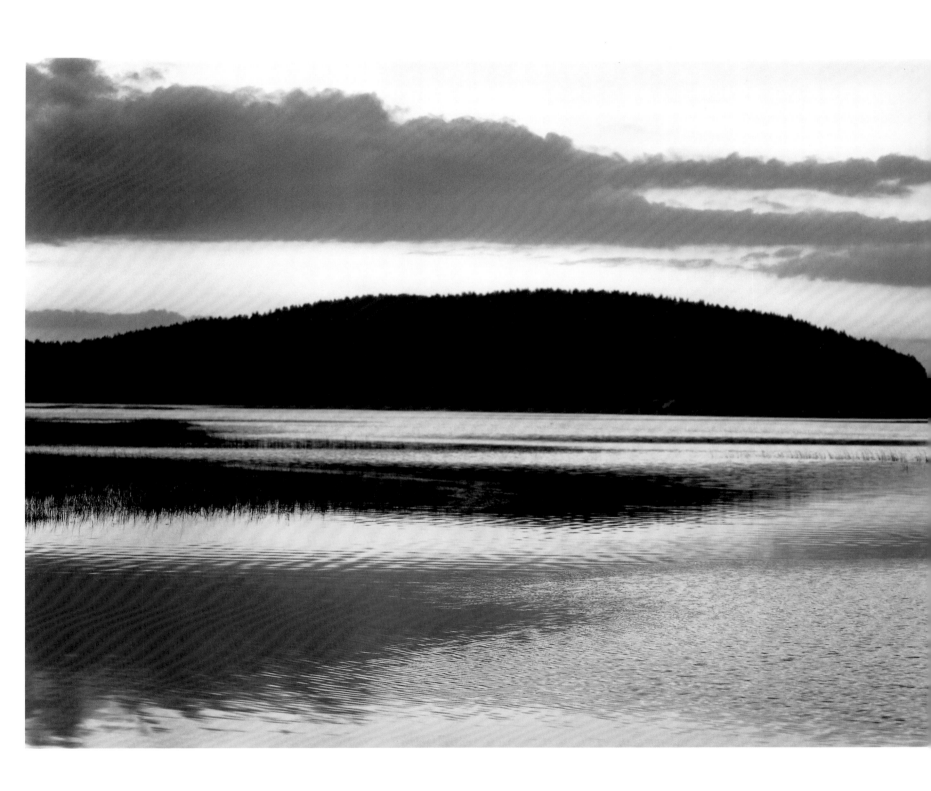

Clouds at Sunrise, Diptych #1, Ipswich, October

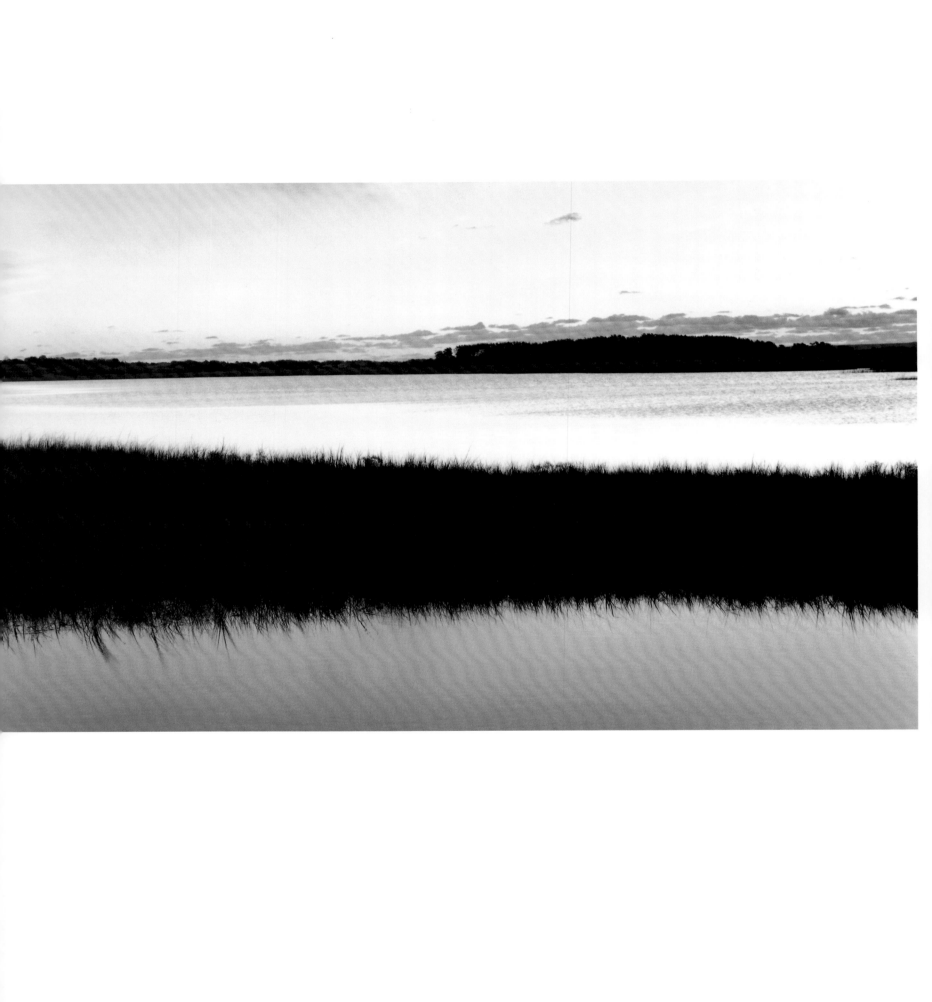

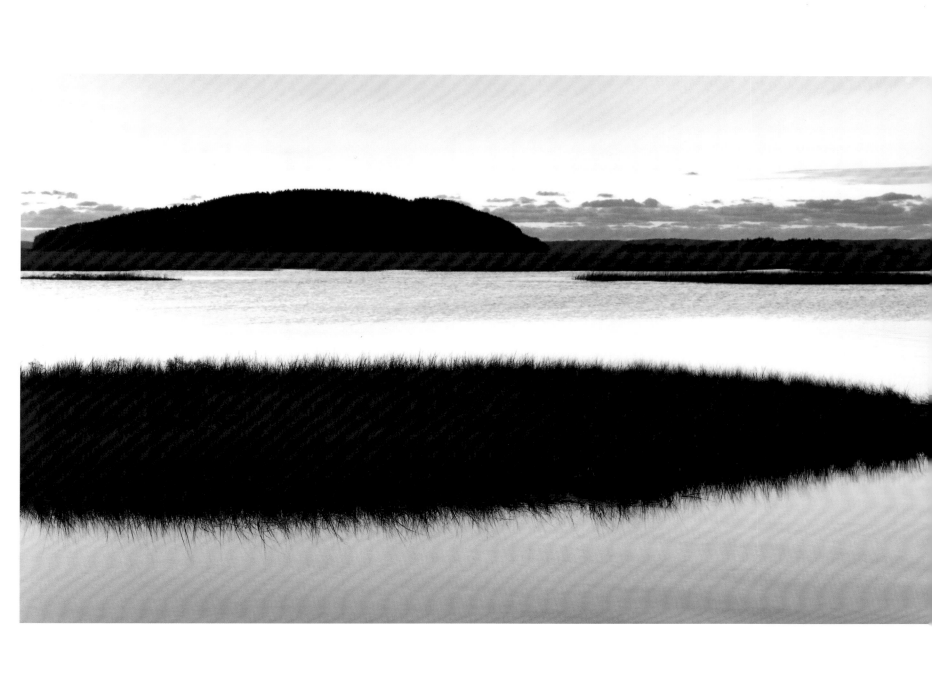

Salt Marsh Islands, Predawn, Diptych #10, Ipswich, October

Spring Tide and Swallow, Ipswich, September

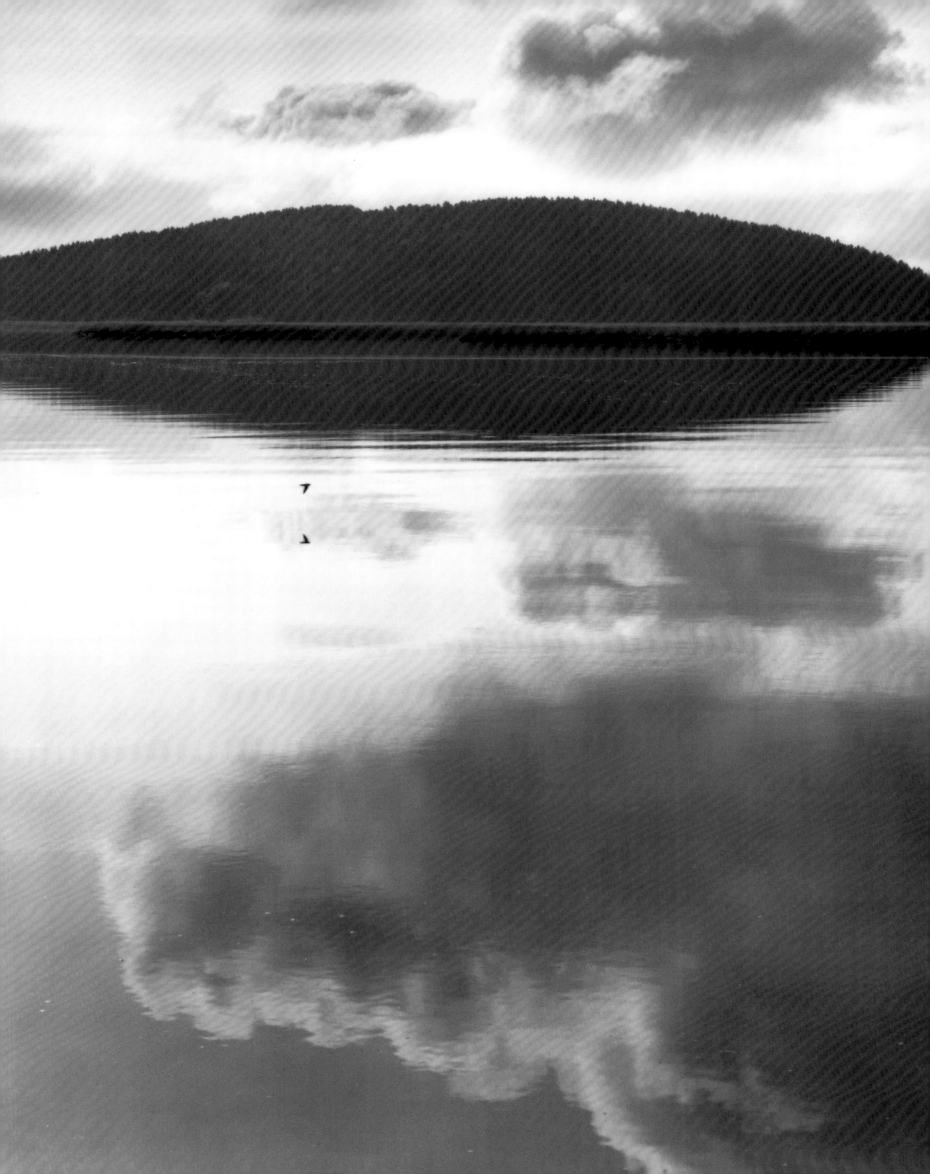

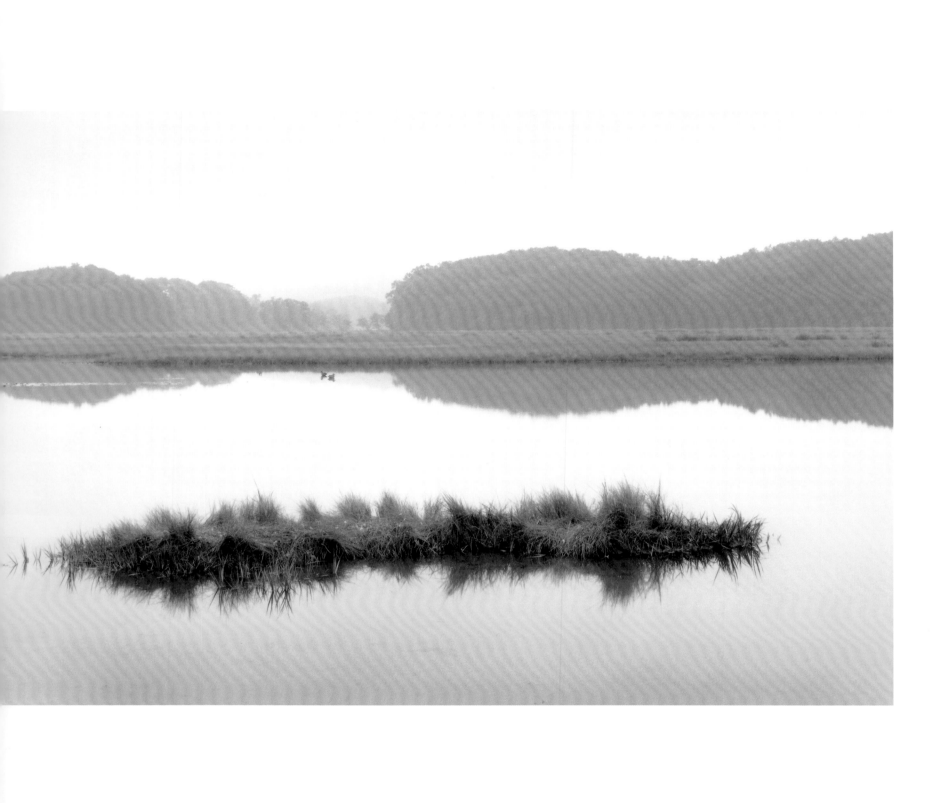

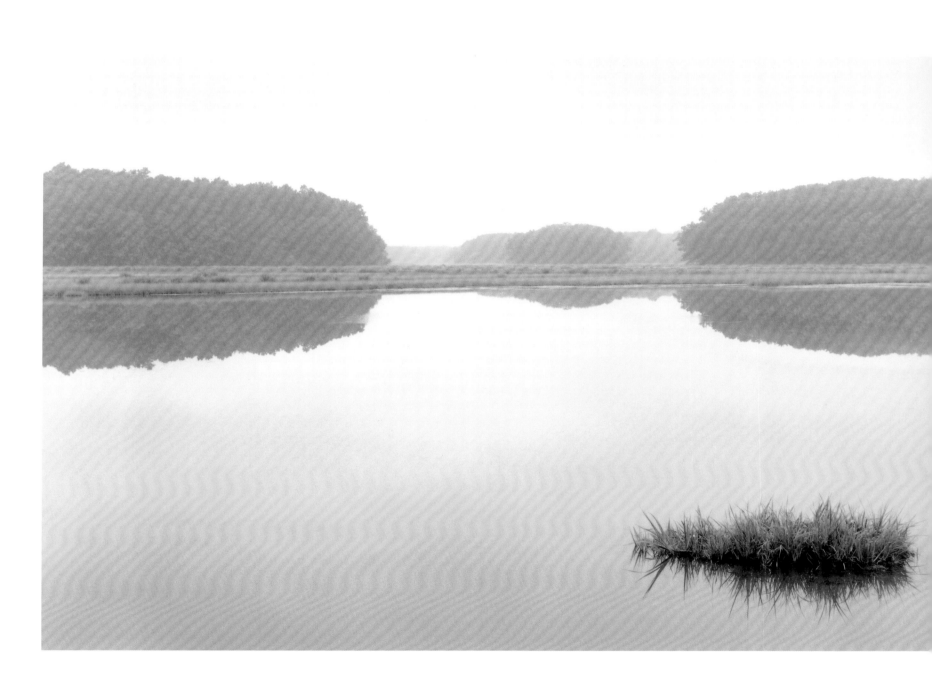

Interior Marsh, Morning Fog, Diptych #4, Ipswich, June

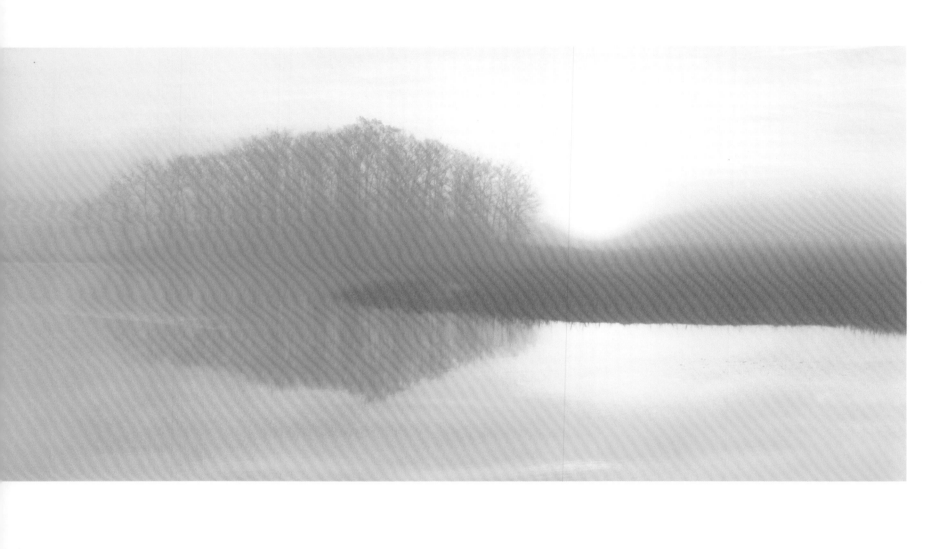

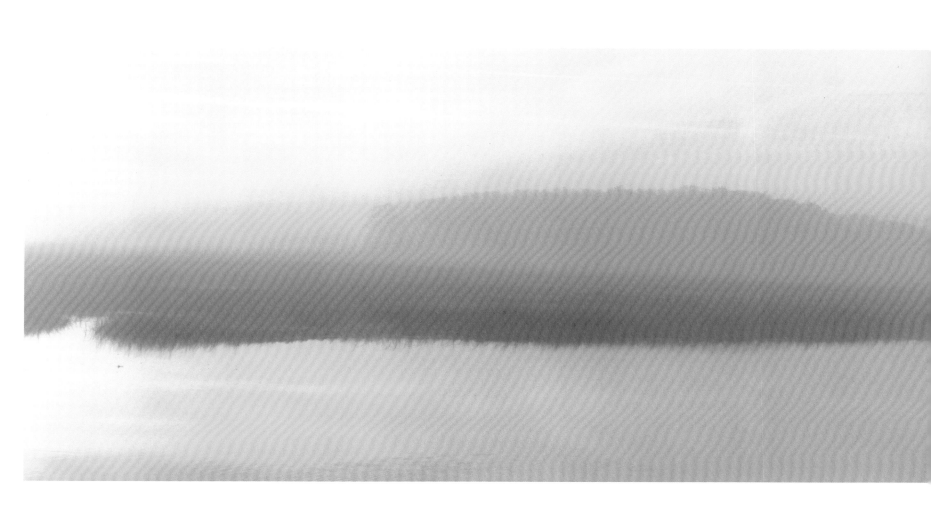

Misty Sunrise, Diptych #13, Ipswich, November

Silhouetted Trees and Hog Island, Spring Tide, Ipswich, January

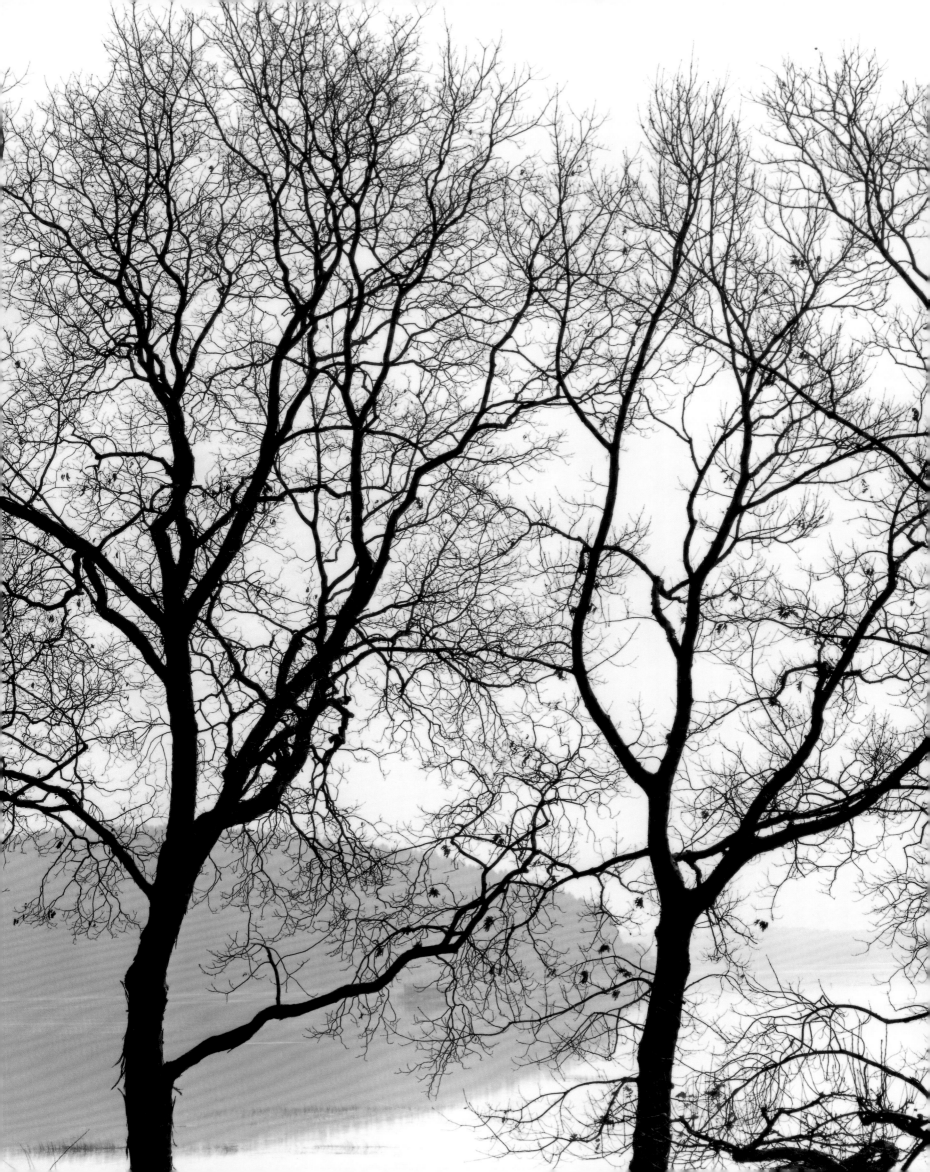

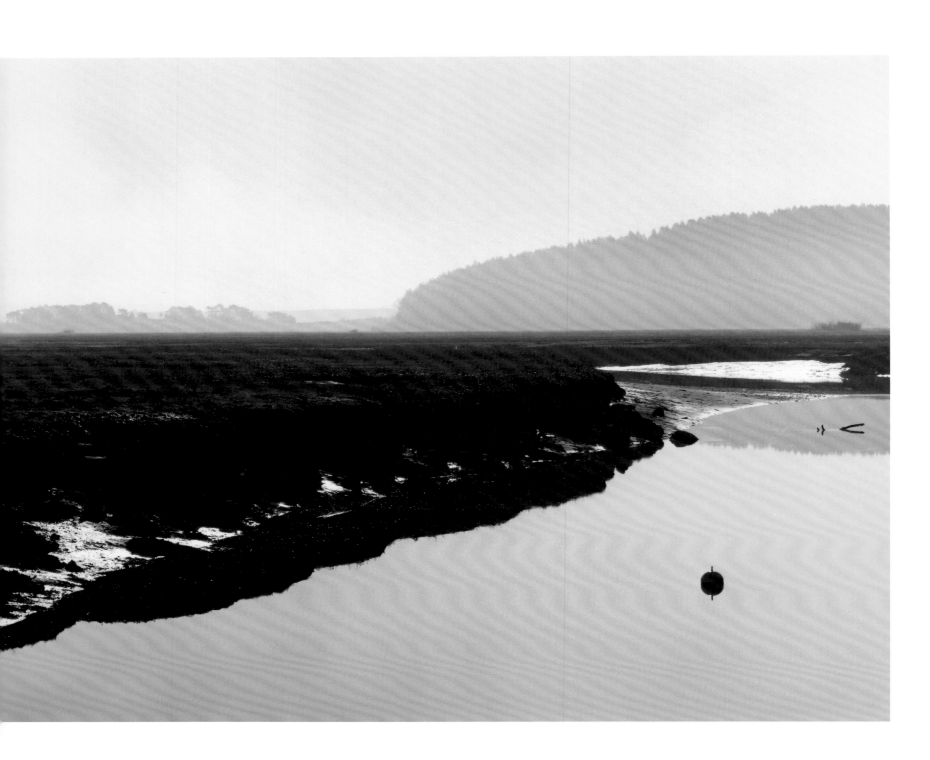

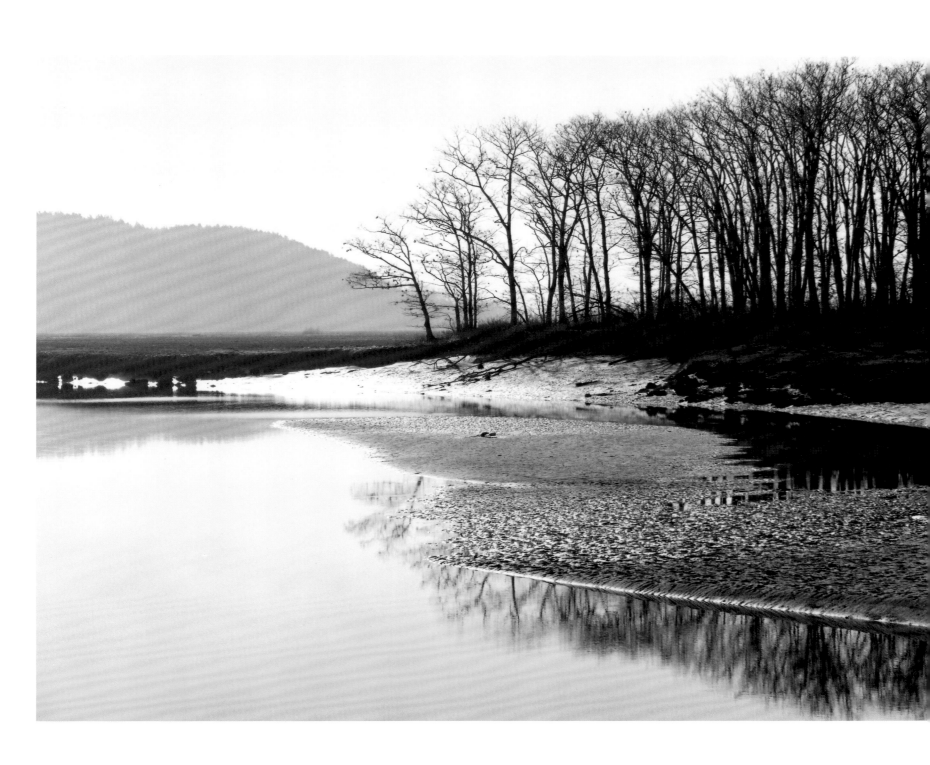

Hog Island, Morning Mist, Diptych #2, Ipswich, April

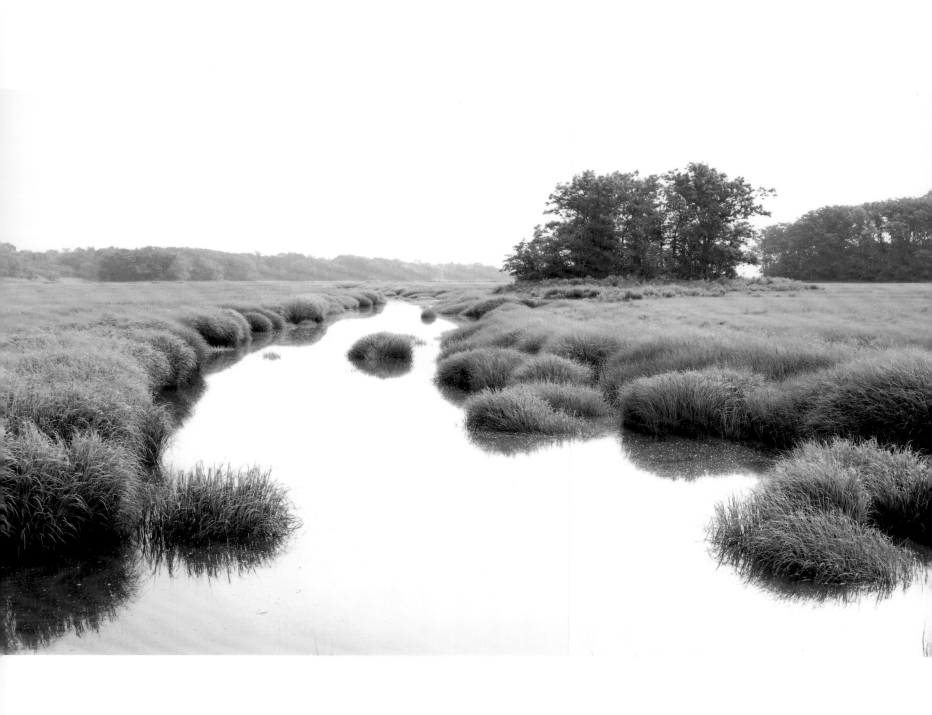

Bright Mist on the Marsh, Parker River, Byfield, June

[overleaf] **A Good Night's Work**, Ipswich, September

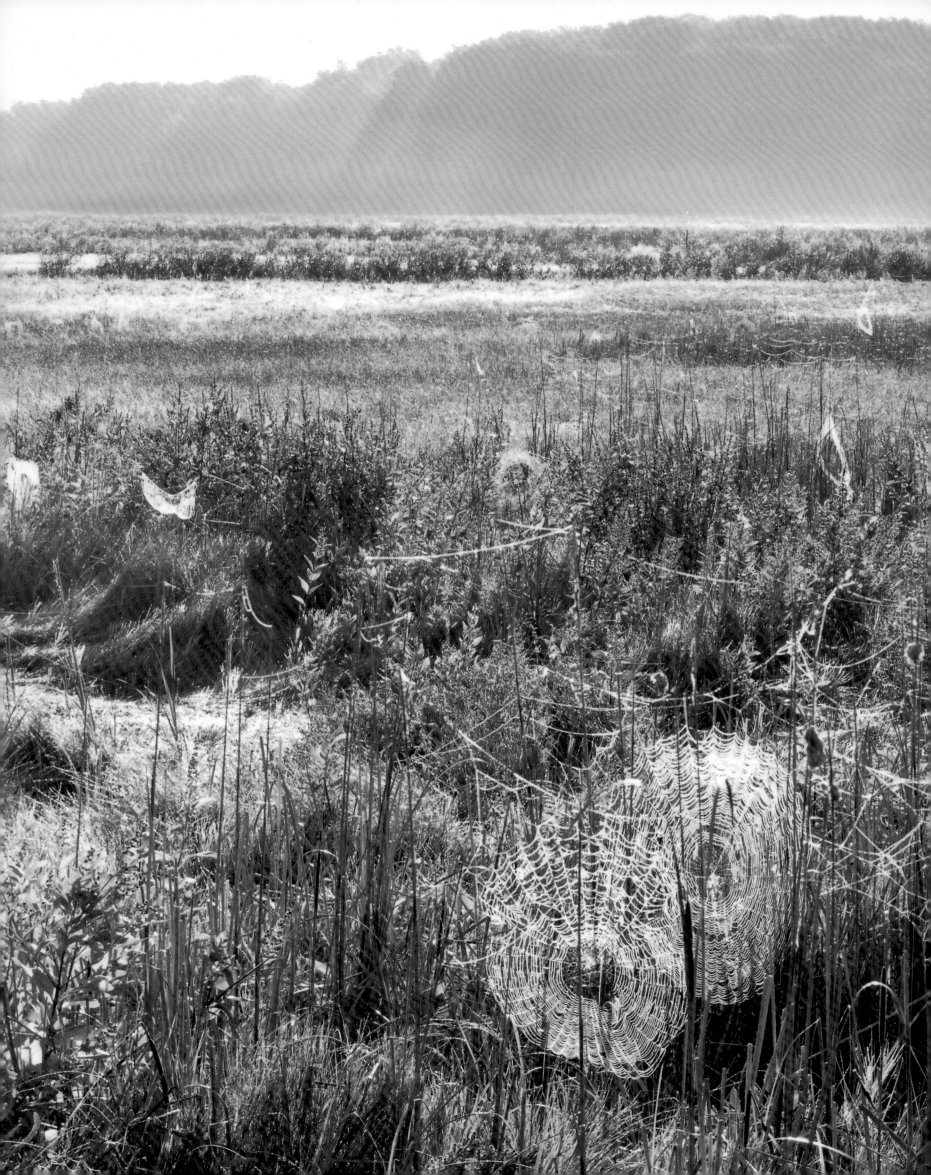

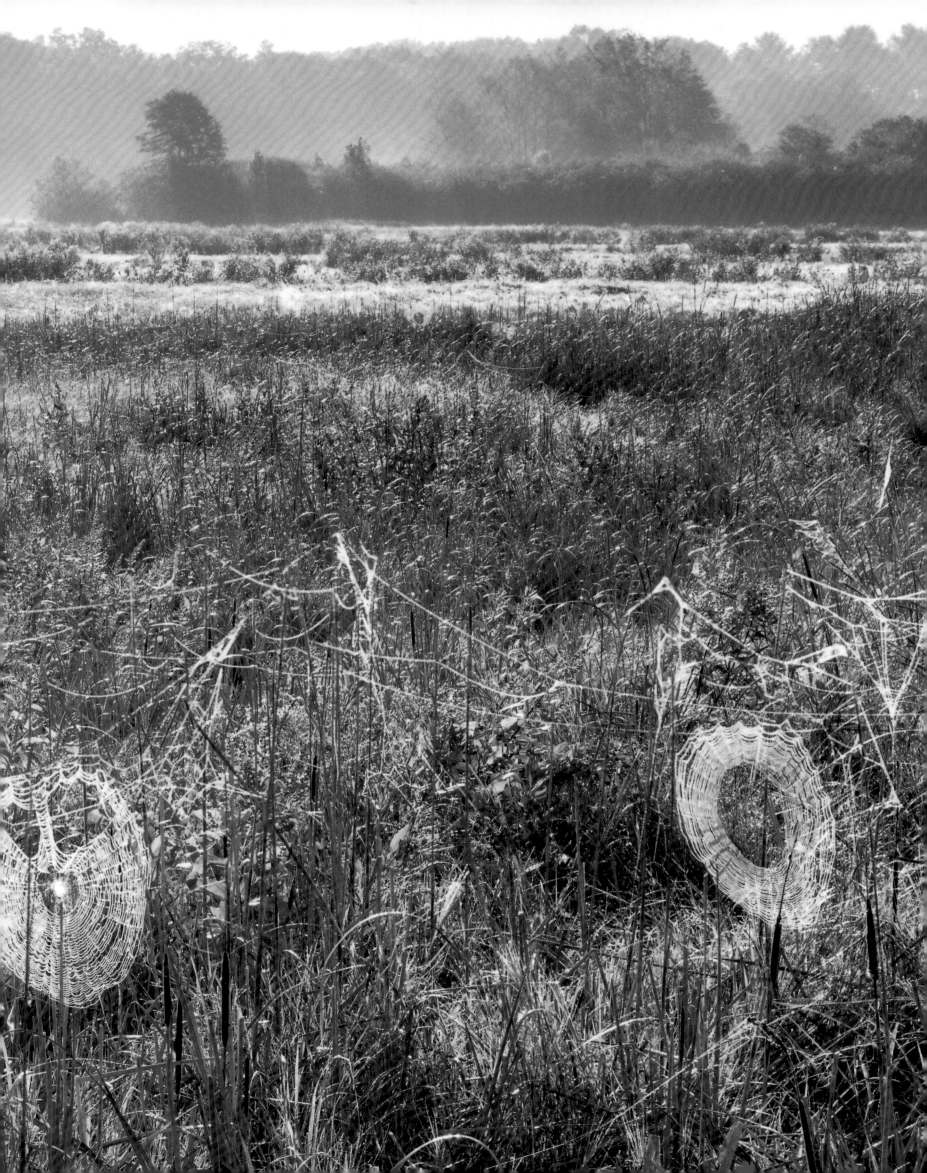

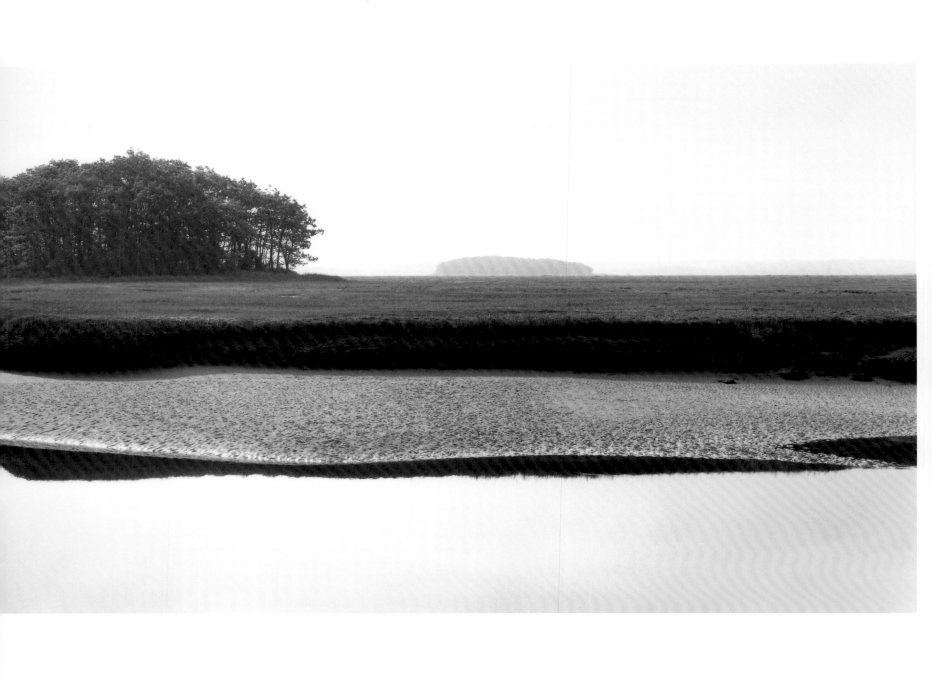

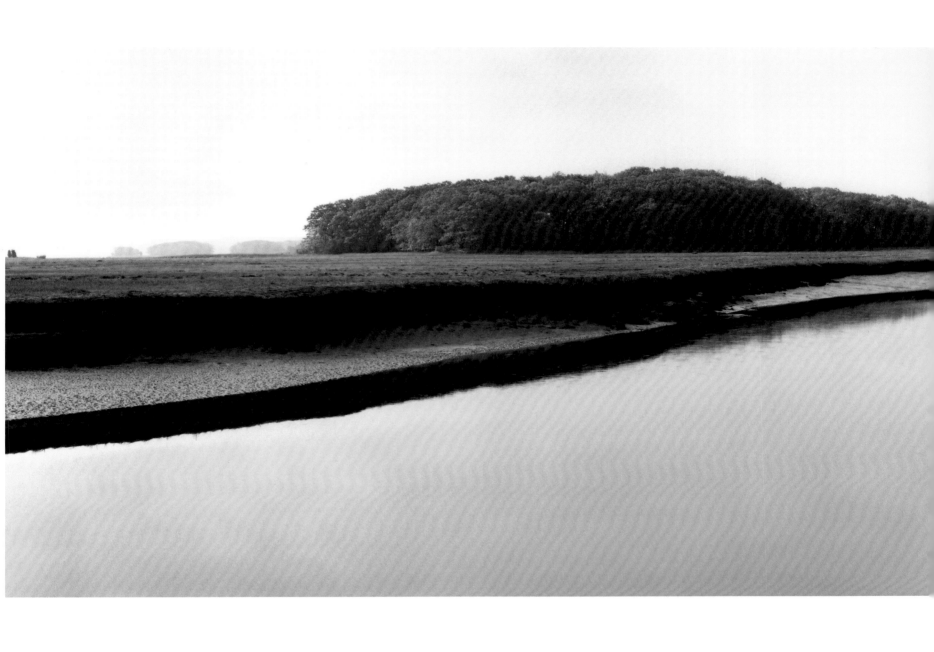

Midtide, Diptych #3, Ipswich, May

Clouds Lifting Over Salt Marsh, Ipswich, November

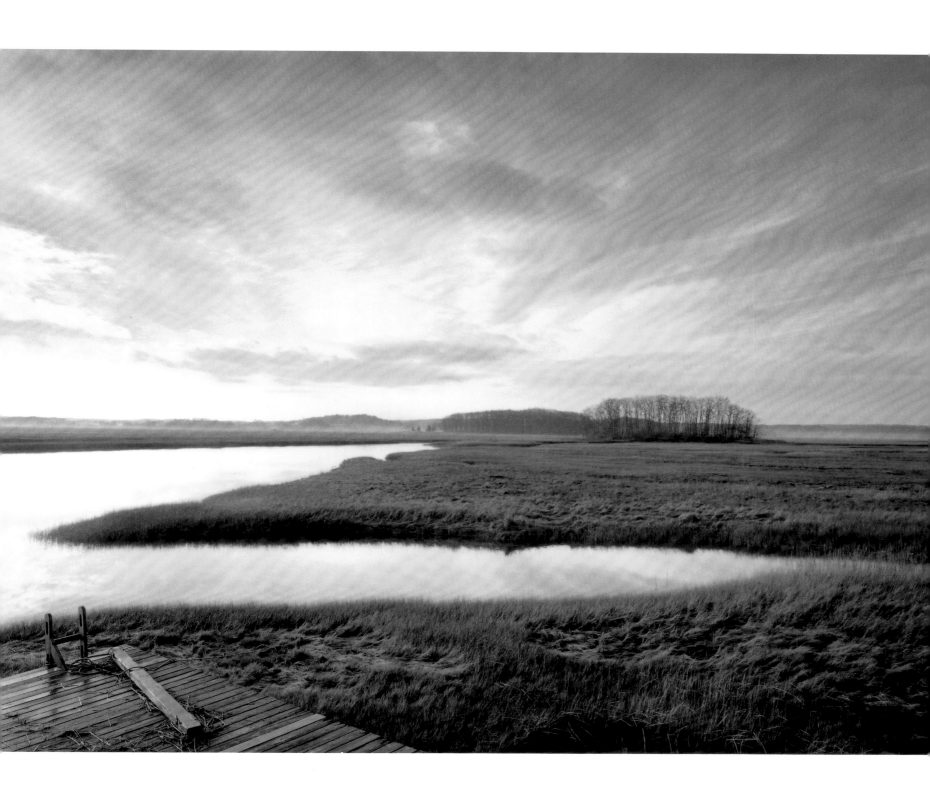

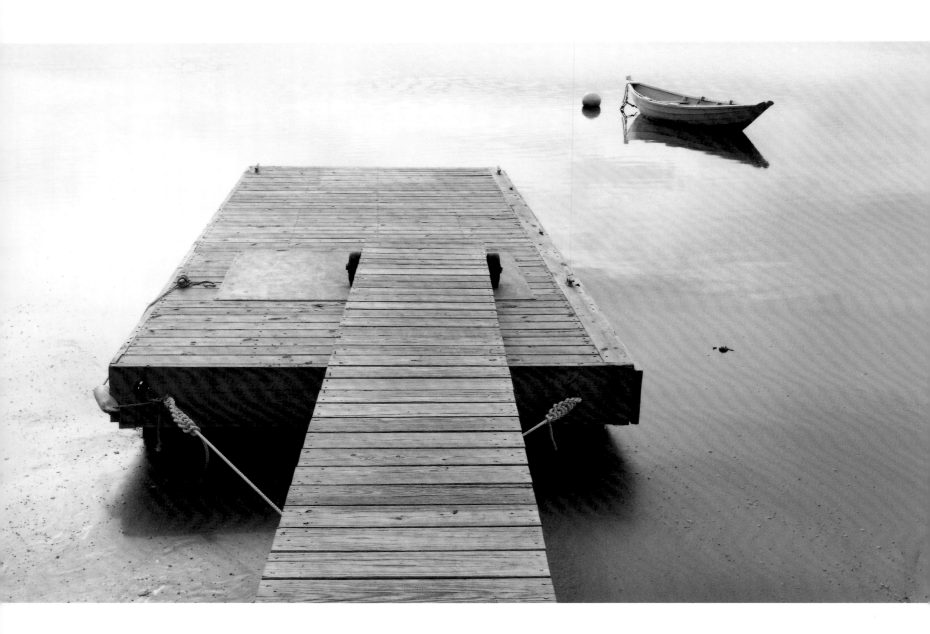

Dock and Dory, Low Tide, Ipswich, November

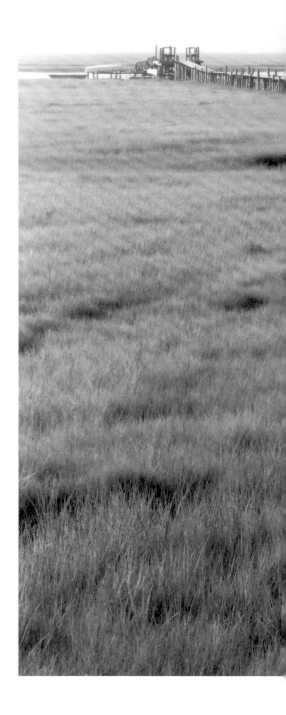

The Boardwalk, Early Morning, Ipswich, July

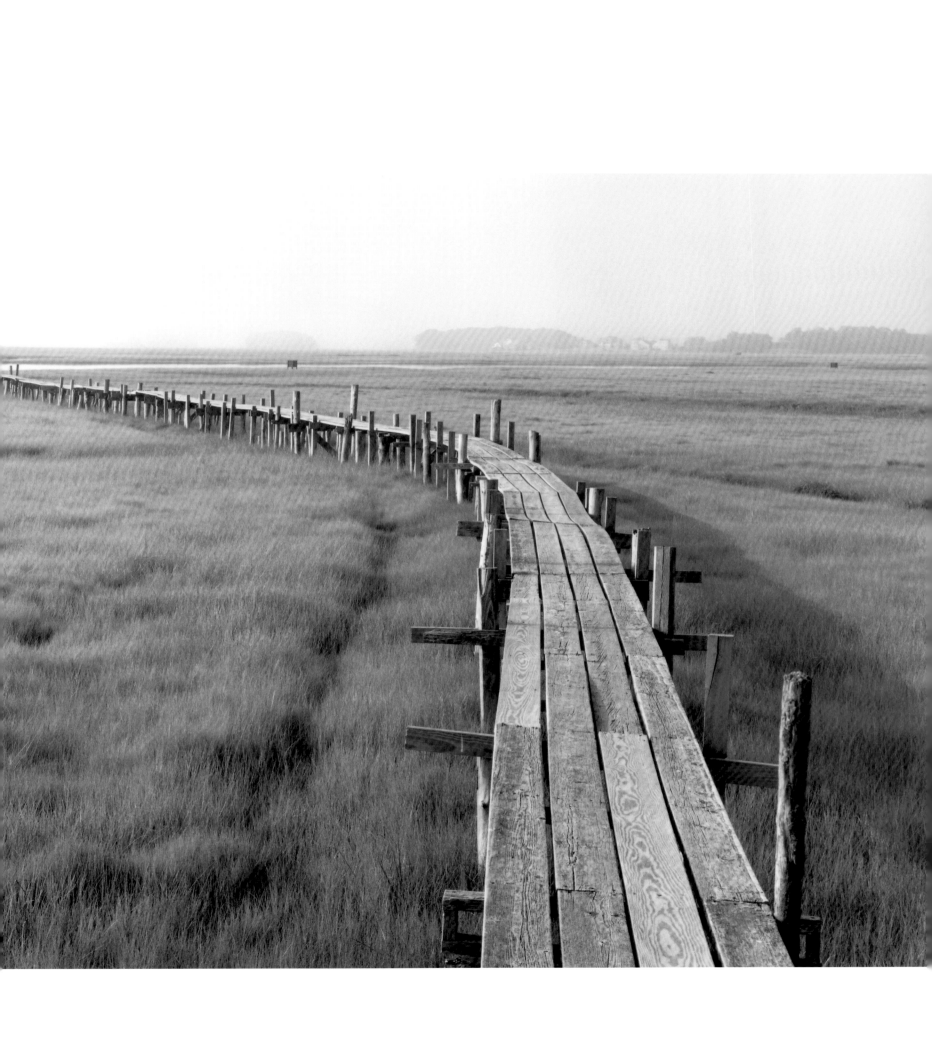

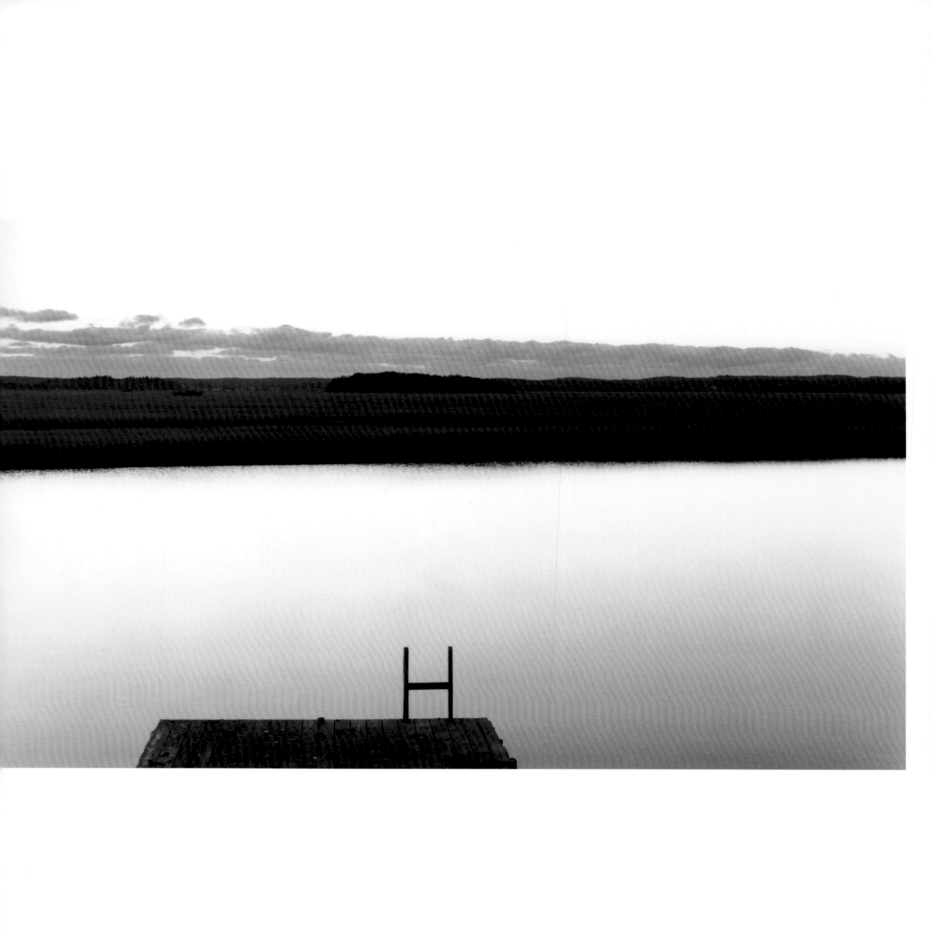

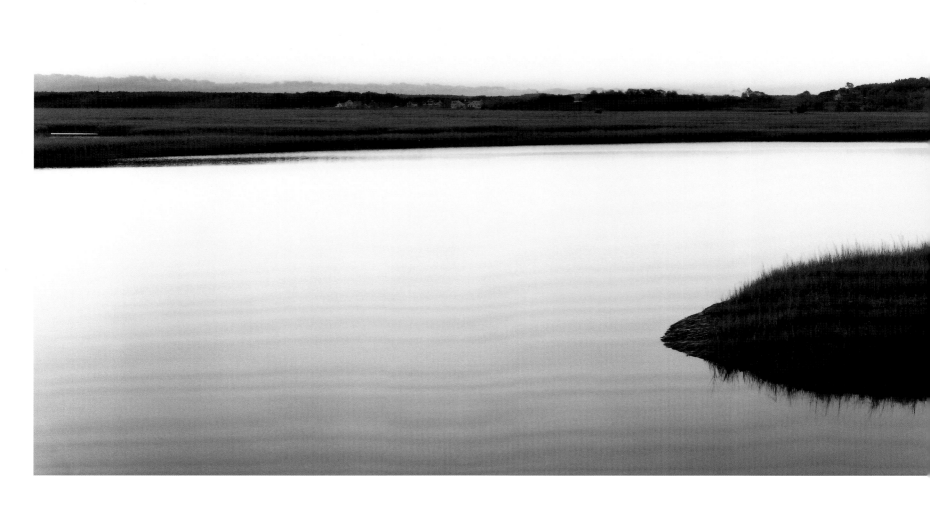

Predawn Stillness, Diptych #9, Ipswich, October

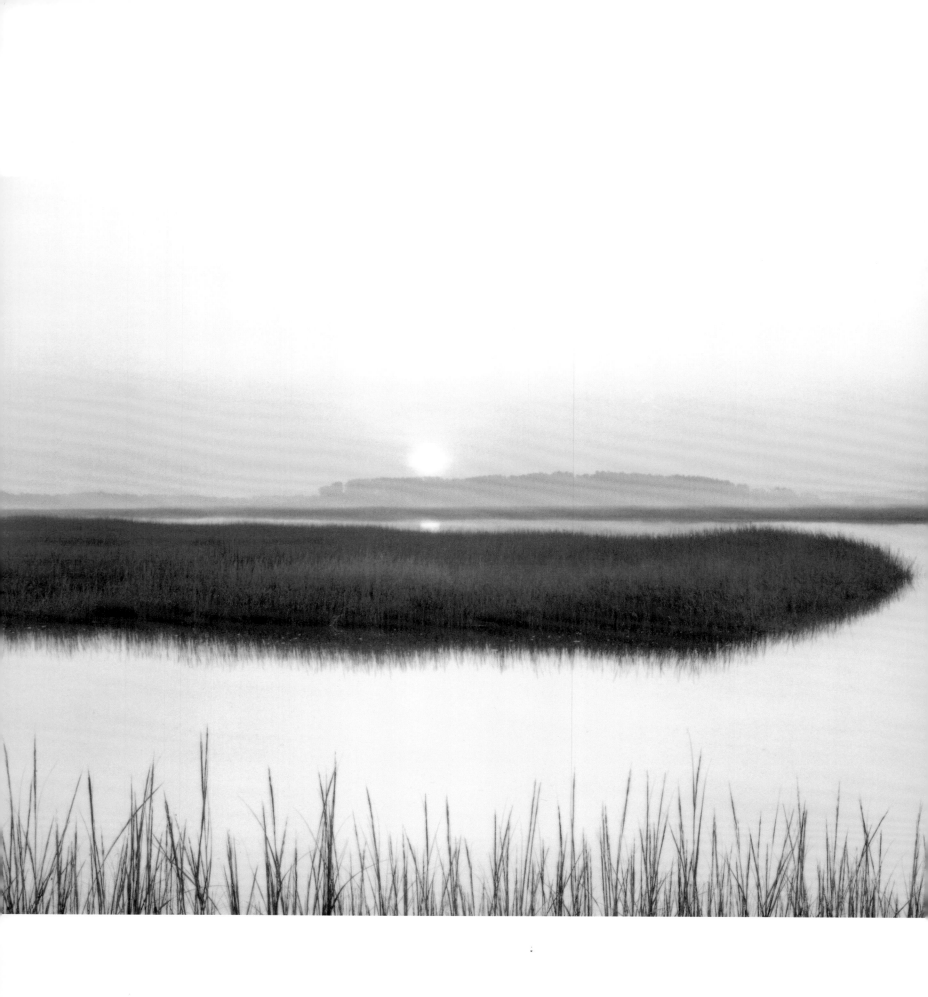

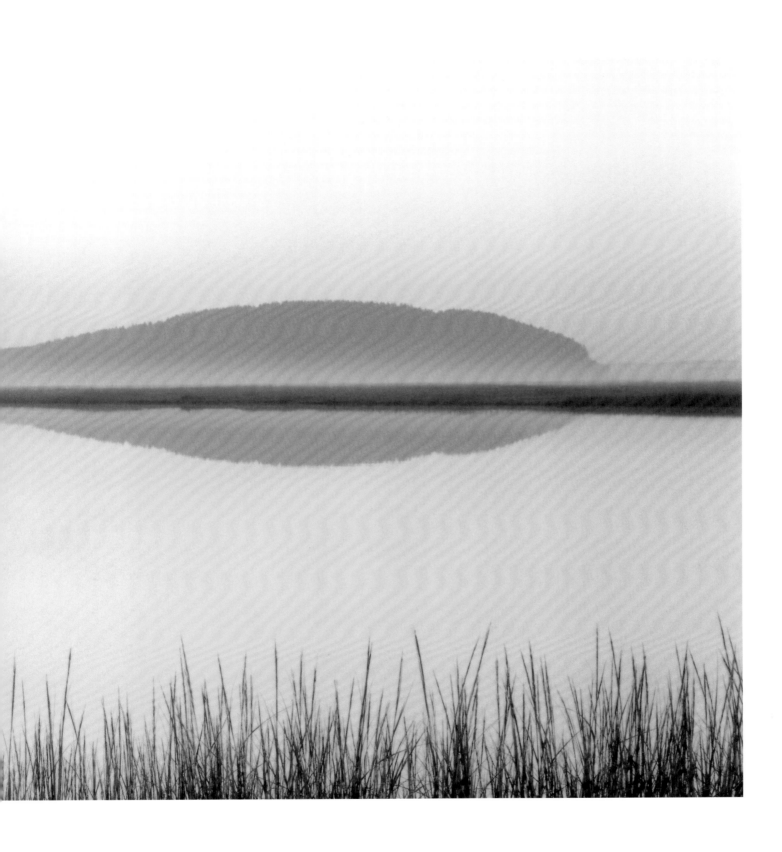

Stillness at Dawn, Ipswich, September

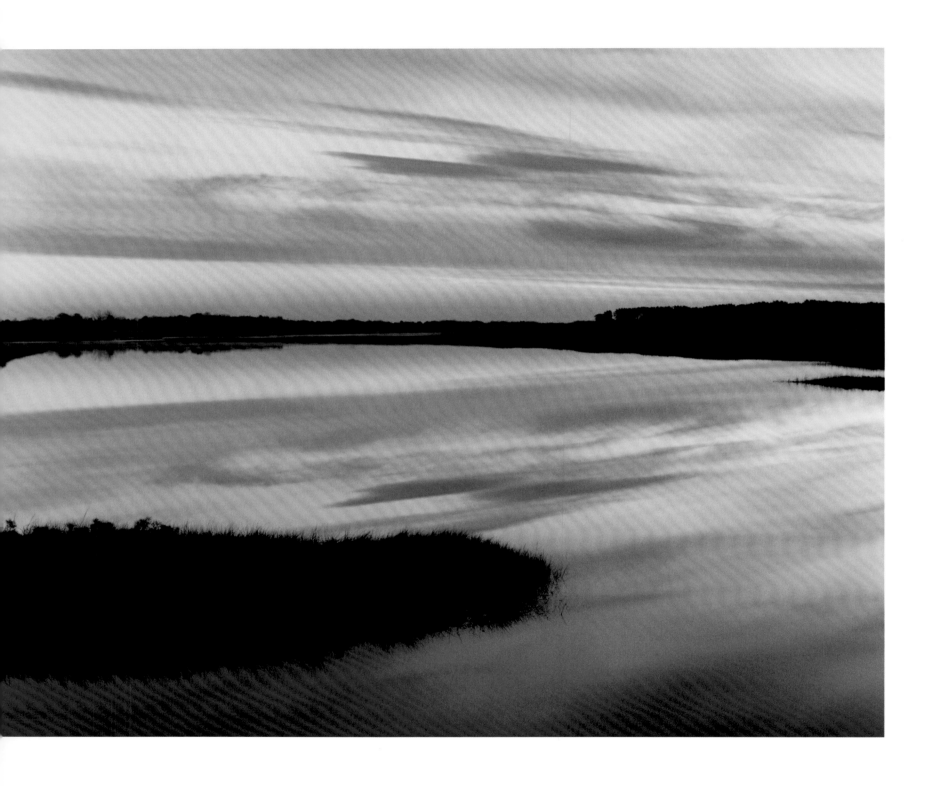

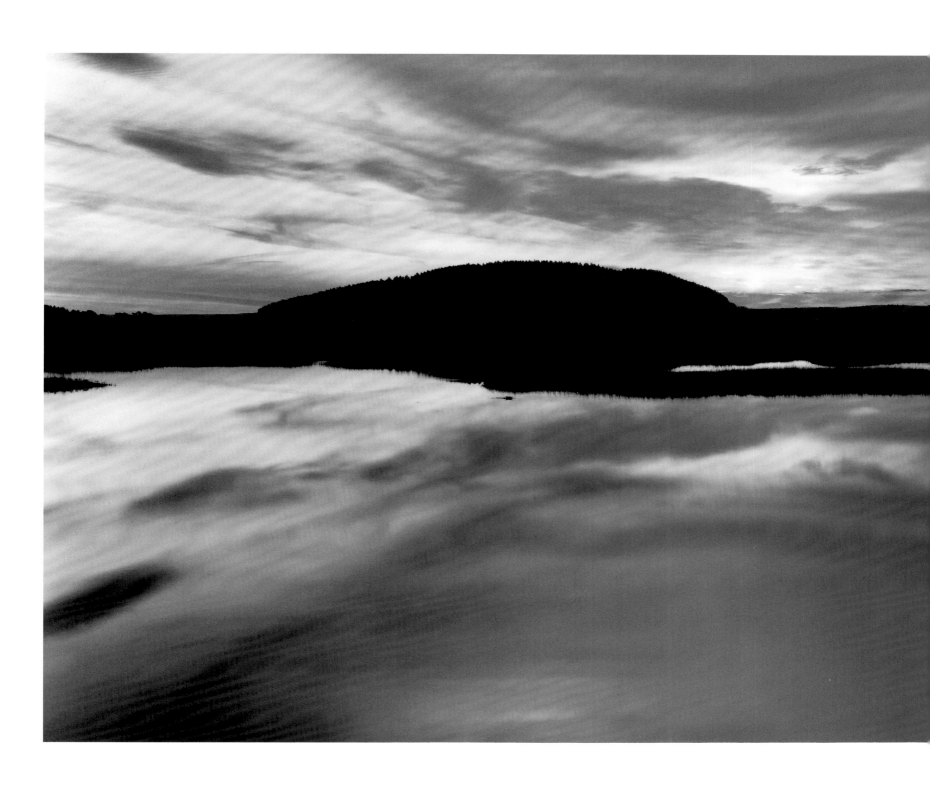

Cloud Pattern, Diptych #15, Ipswich, November

Daybreak, Winter Marsh, Ipswich, January

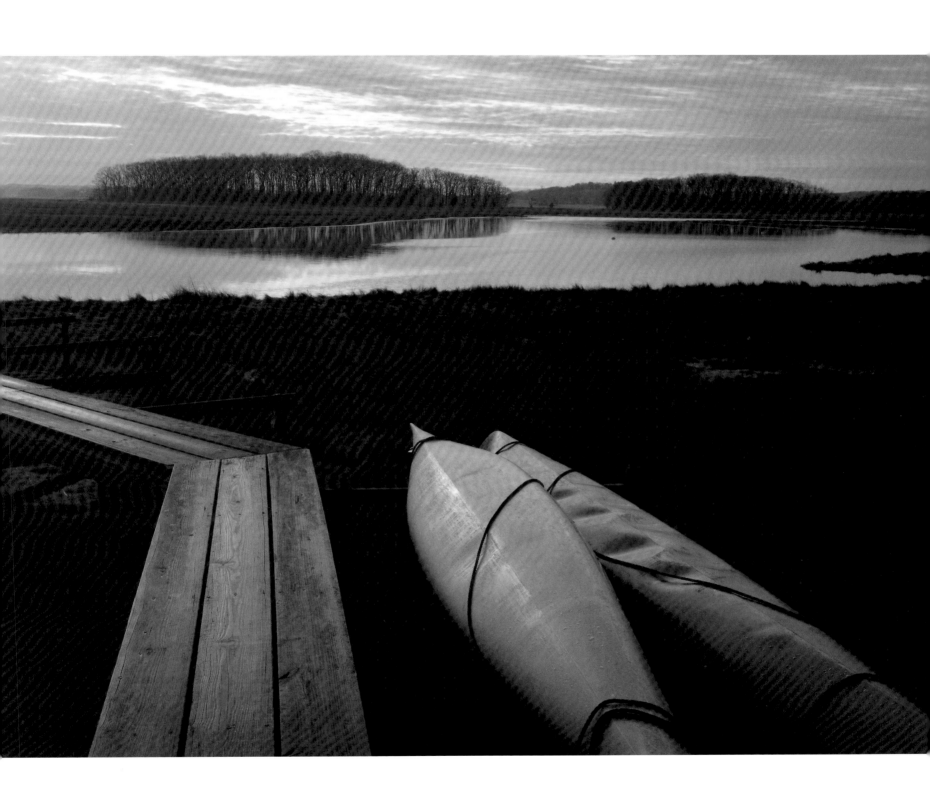

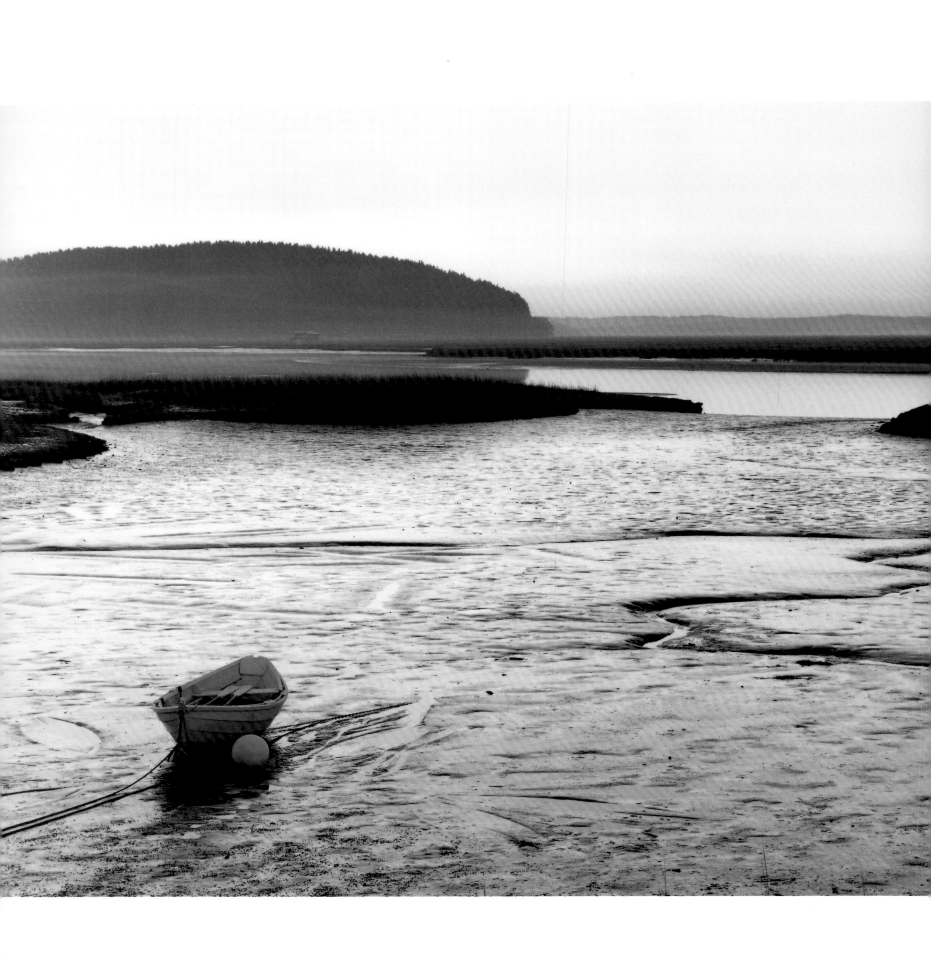

Dory, Low Tide, Dawn, Ipswich, November

Salt Marsh at Dusk, Ipswich, November

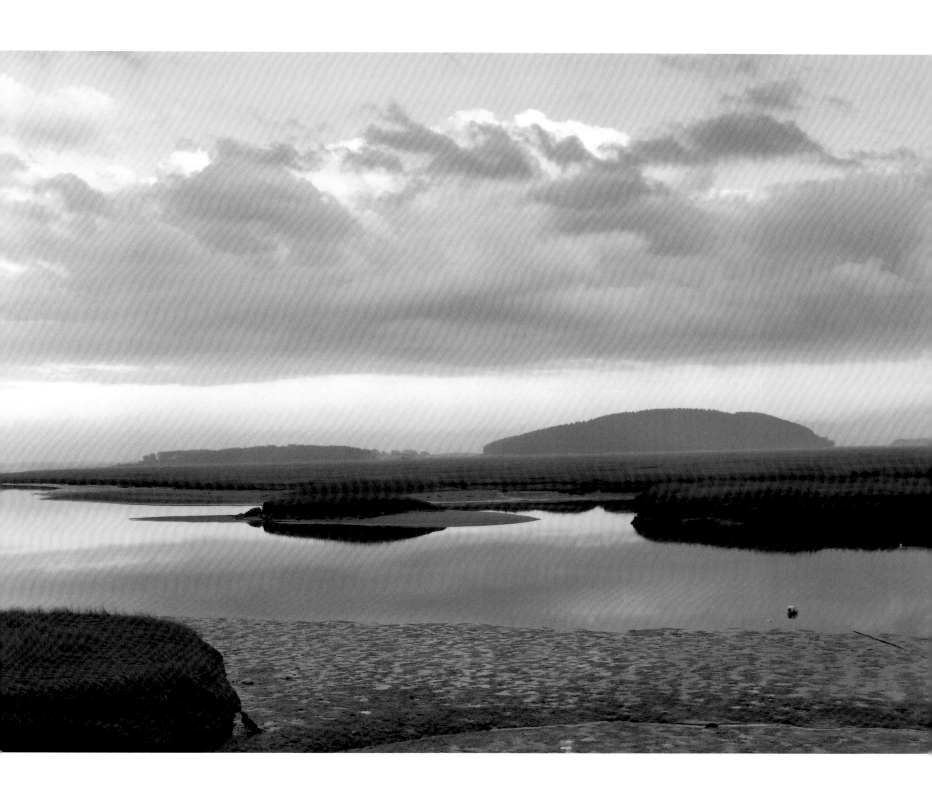

Salt Hay, First Light, Stoney Cove, Gloucester, September

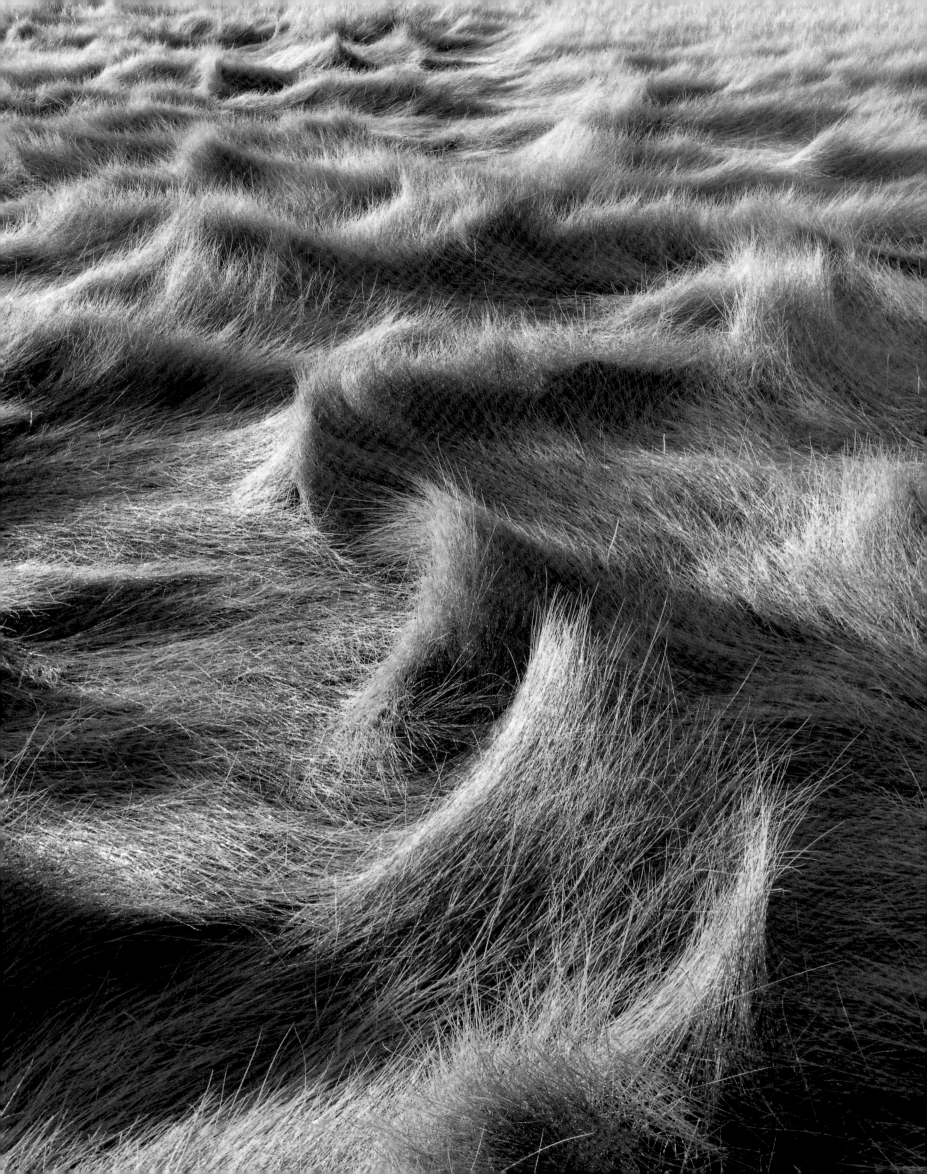

Oak Leaves and Salt Hay, Ipswich, May

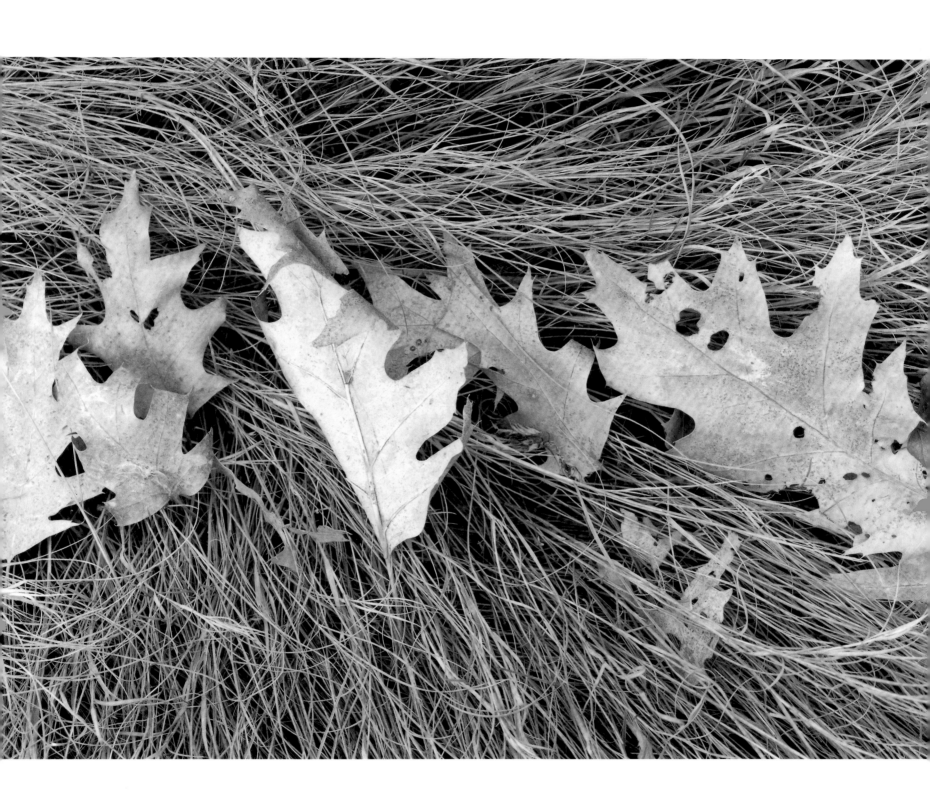

May Marsh, Ipswich, May

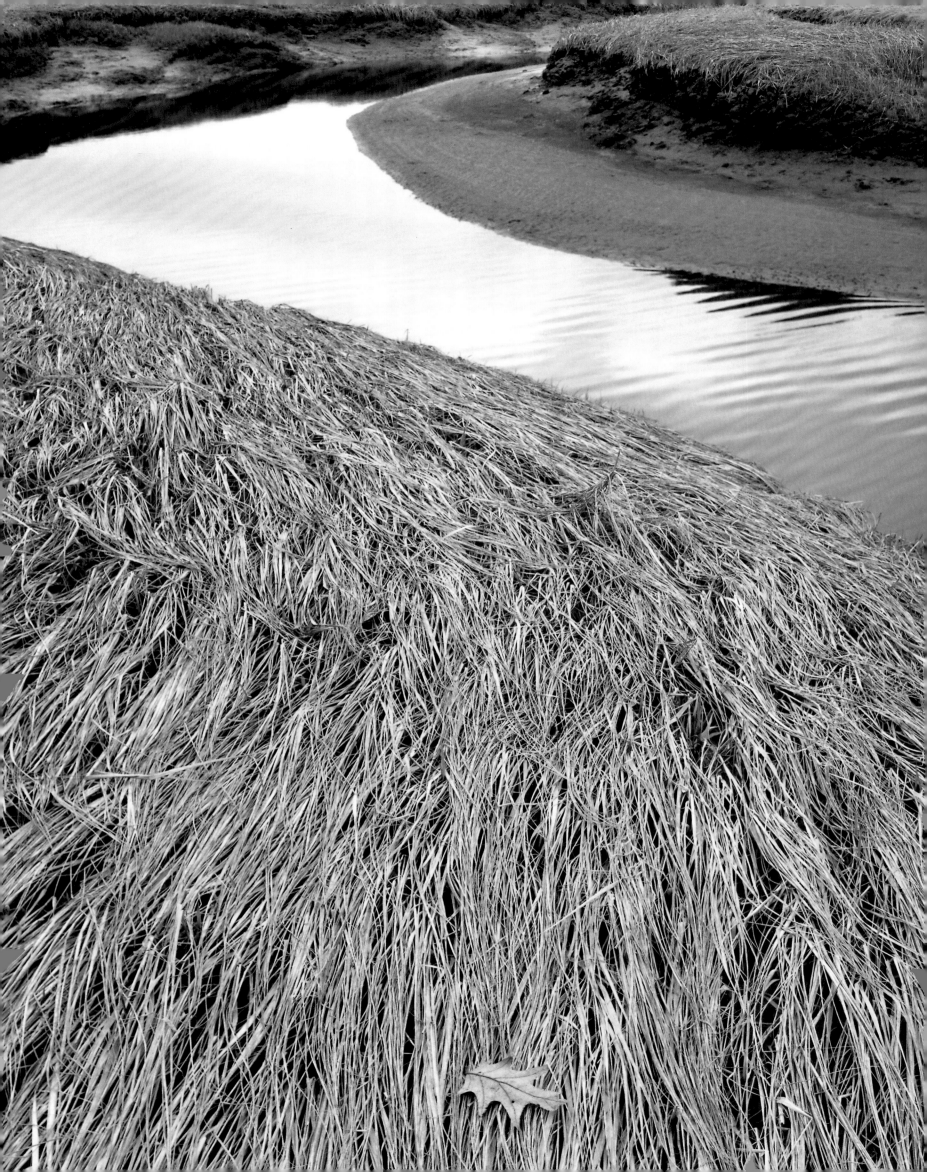

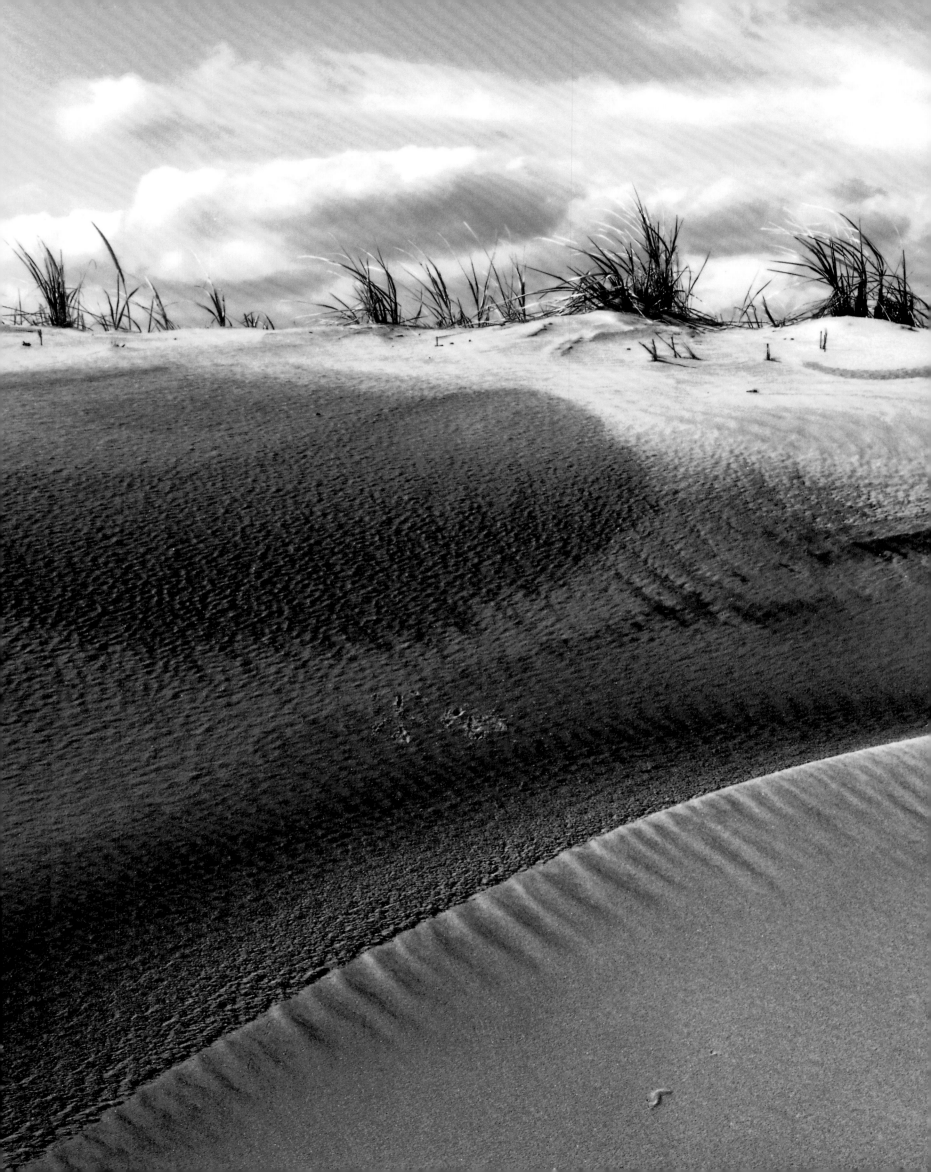

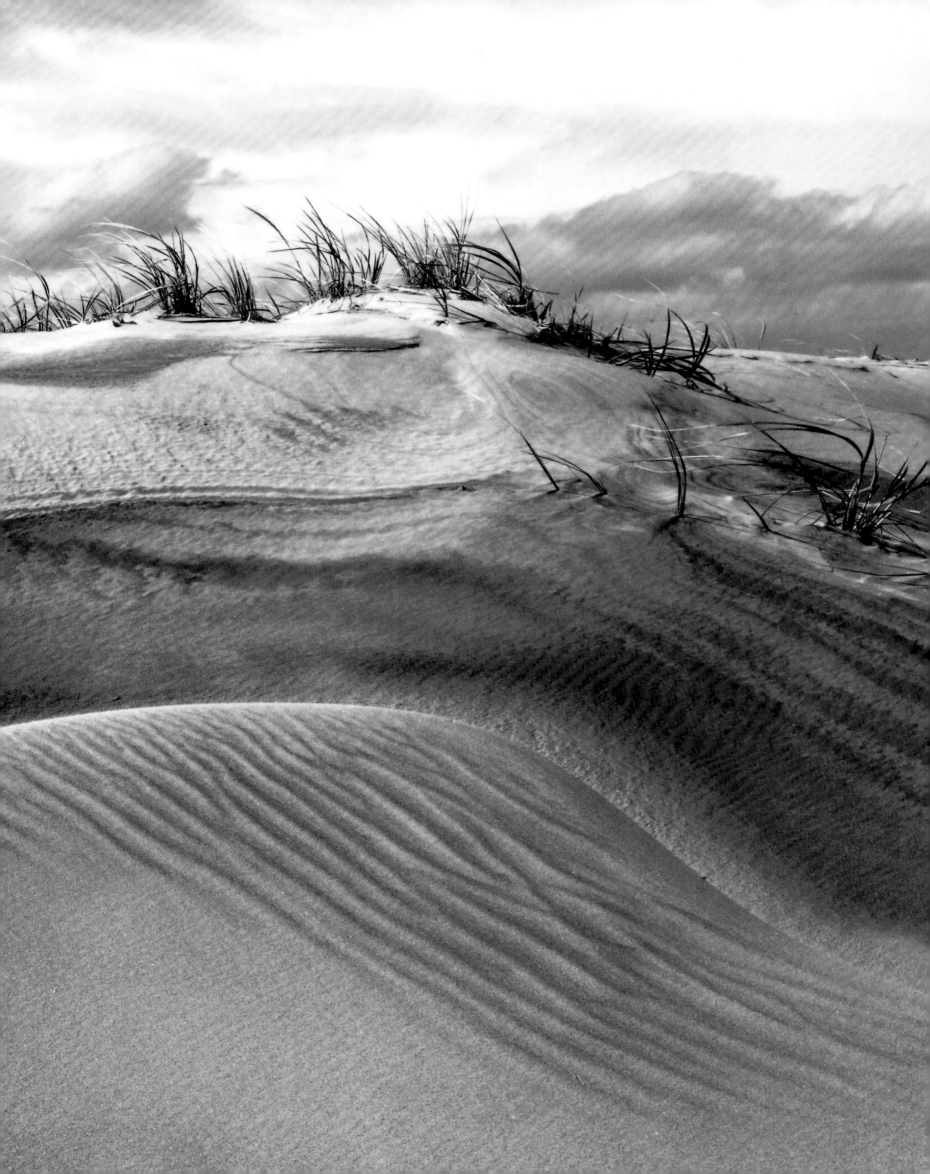

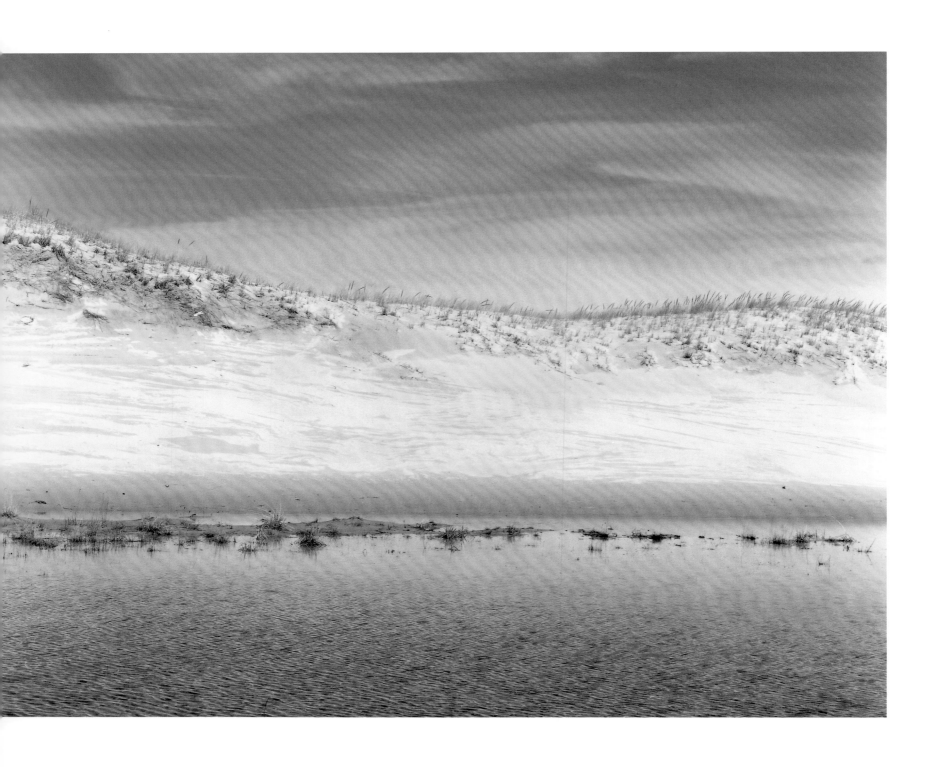

[overleaf] **Dune, Autumn**, Crane Beach, Ipswich, October

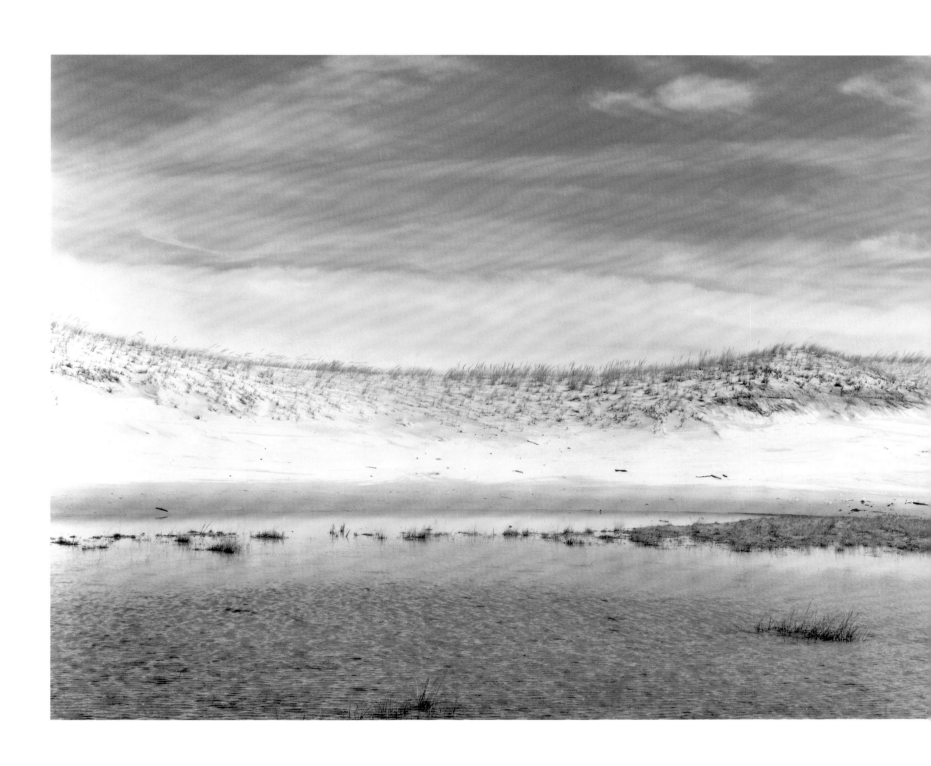

Interior Dune and Pool, Diptych #12, Crane Beach, Ipswich, April

Wave Memory #1, Crane Beach, Ipswich, September

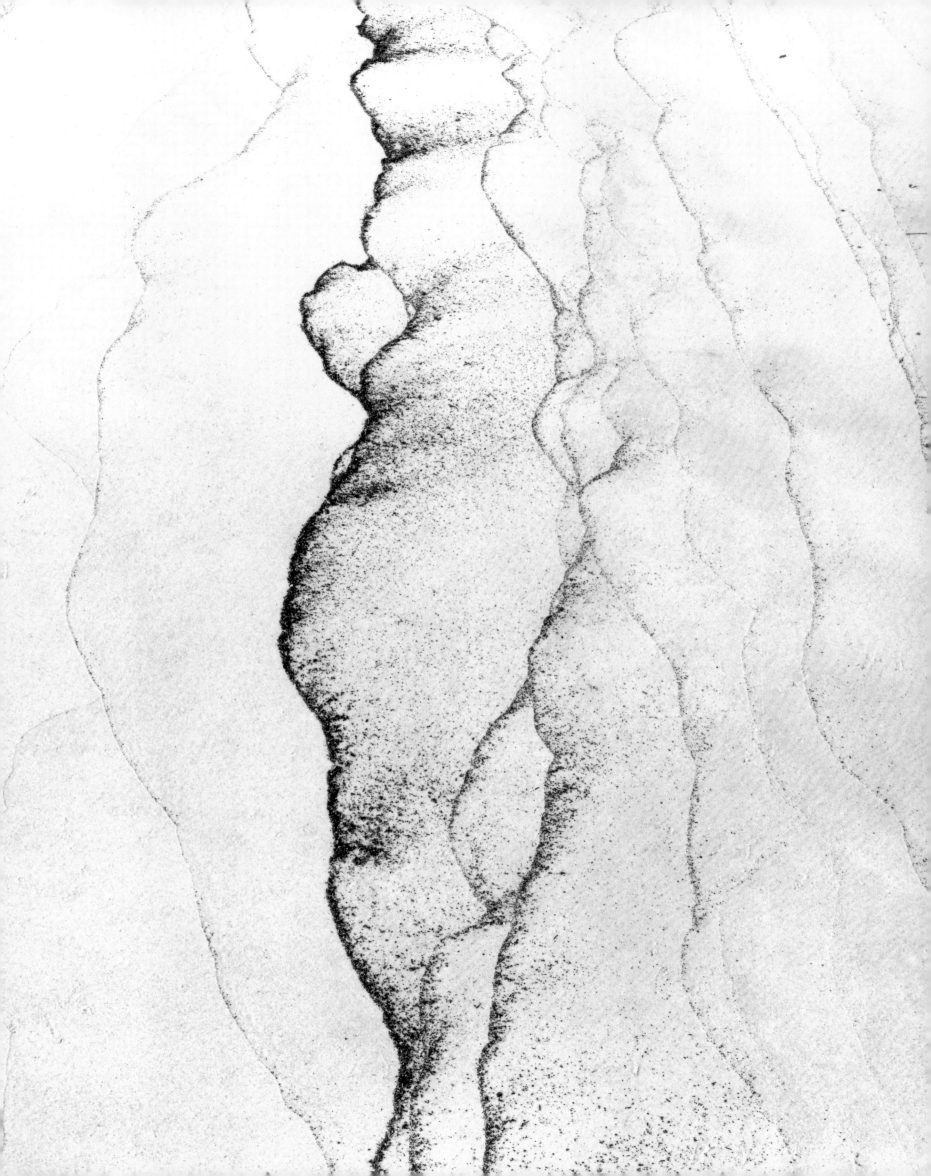

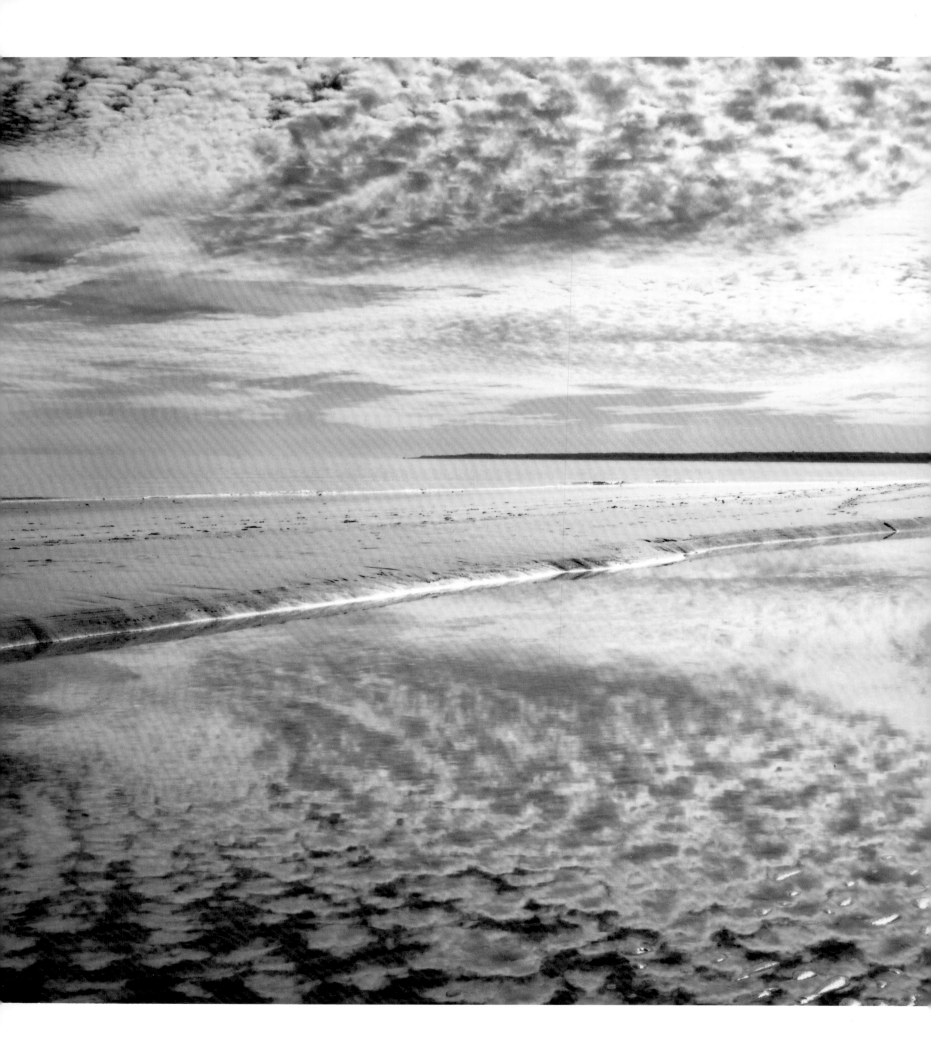

Cloudscape #1, Crane Beach, Ipswich, August

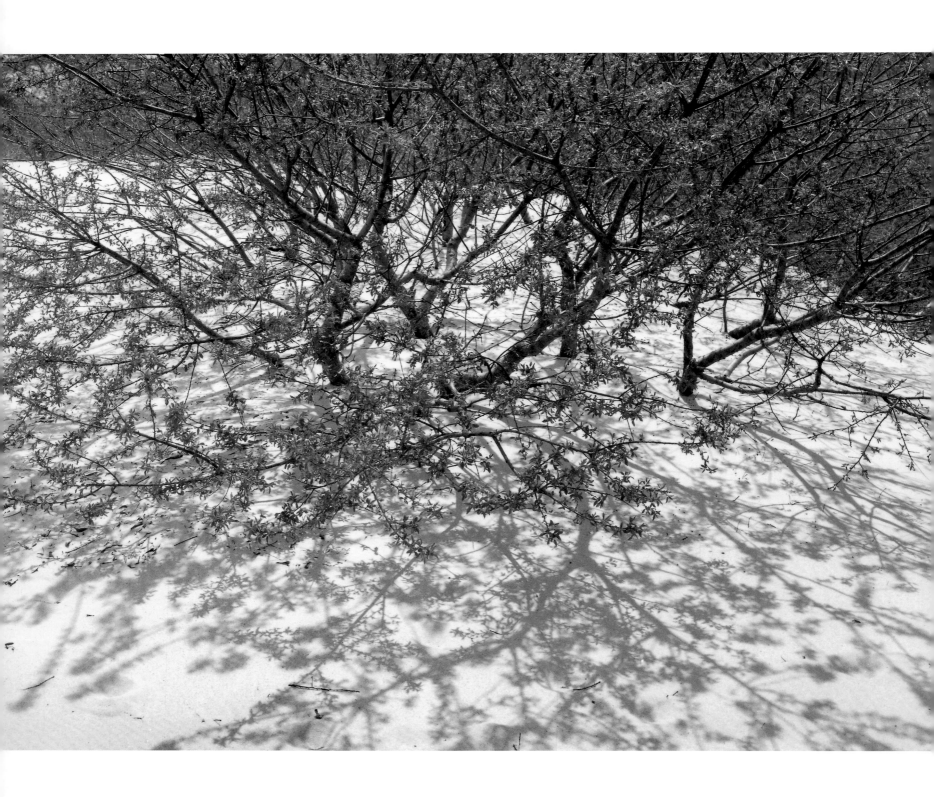

Red Maple and Drifting Dune #2, Crane Beach, Ipswich, June

[overleaf] **Salt Marsh Island, Winter**, Ipswich, January

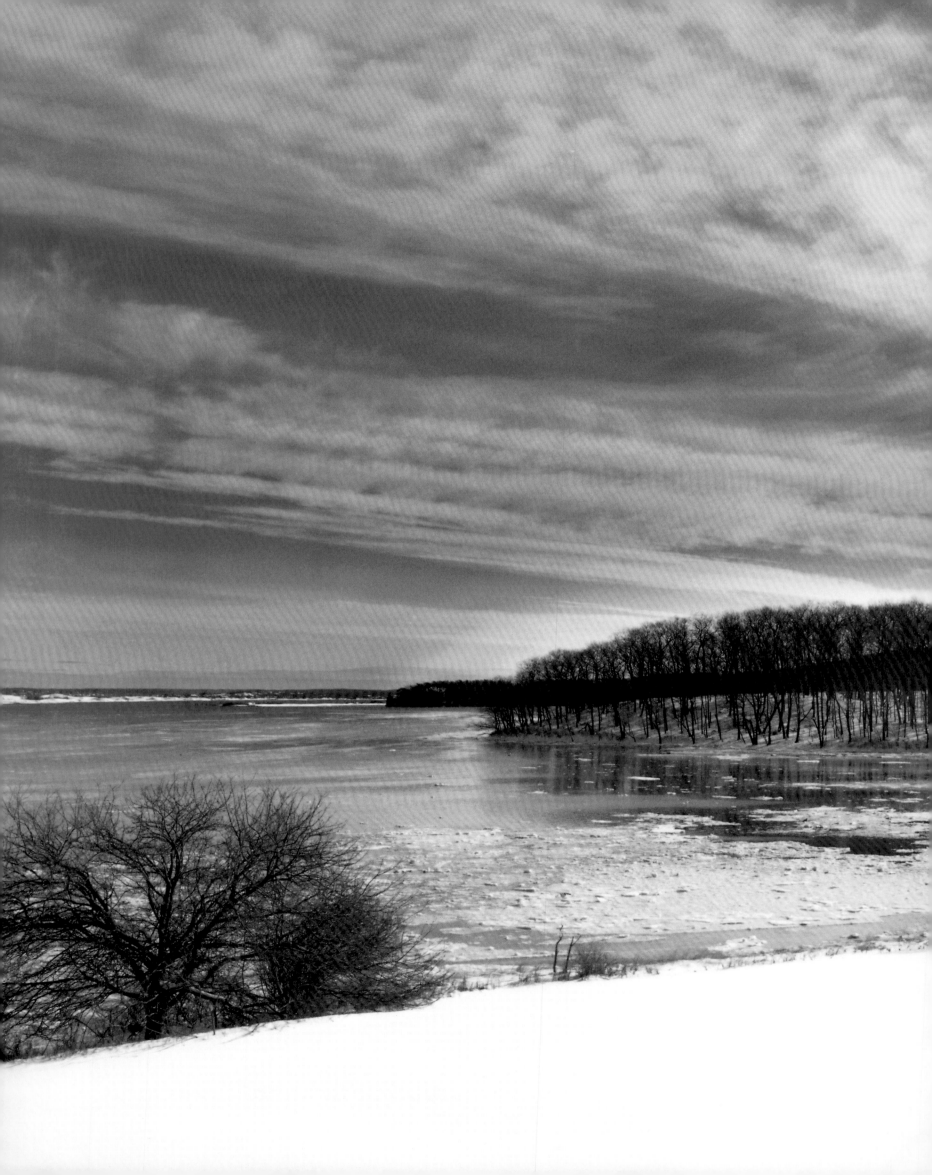

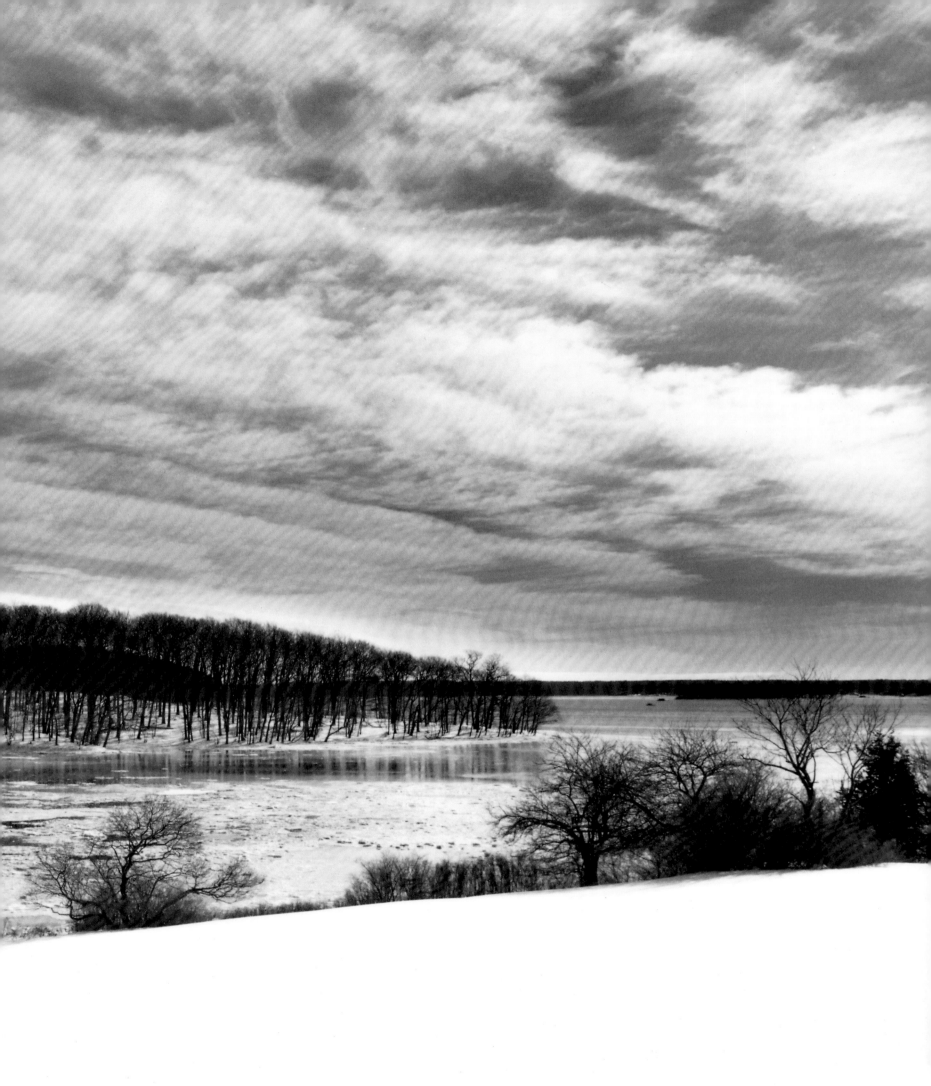

Sycamore, Melting Snow, Ipswich River Wildlife Sanctuary, Topsfield, January

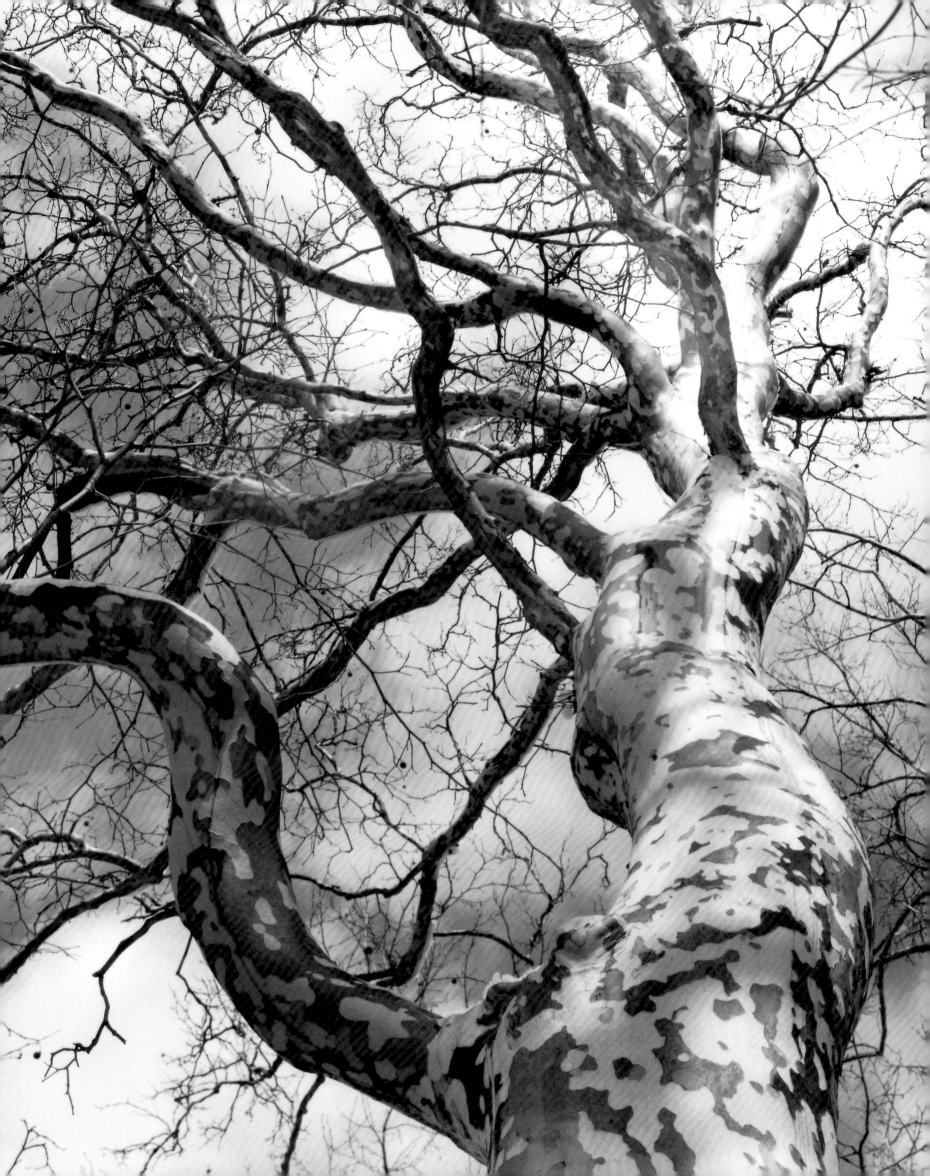

Melting Ice, Ipswich River, Boxford, January

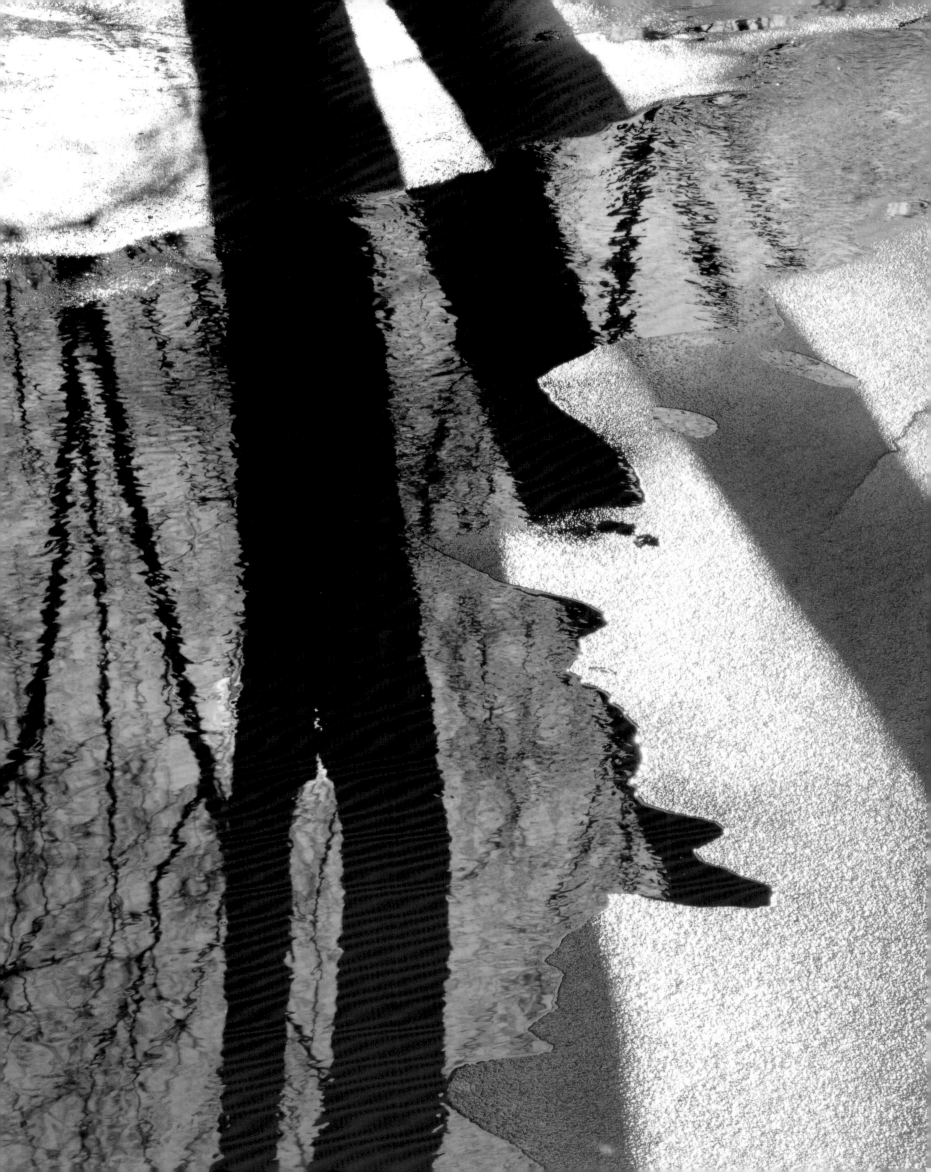

Ice Pattern #9, Gravelly Brook, Ipswich, December

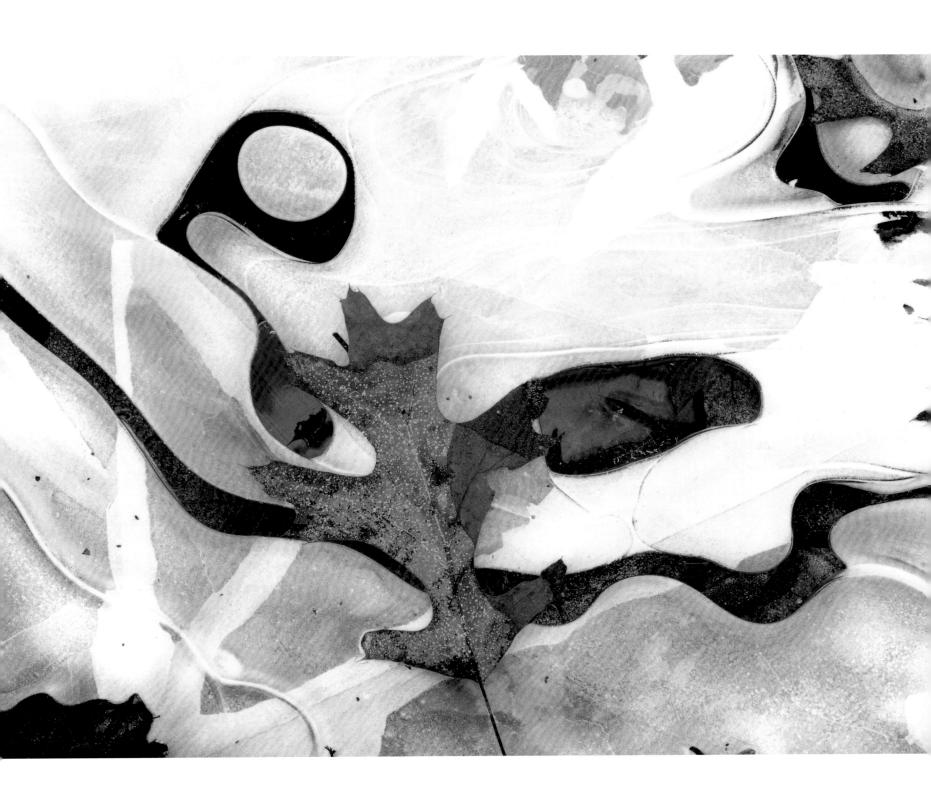

Ice Pattern #8, Pond, Ipswich, January

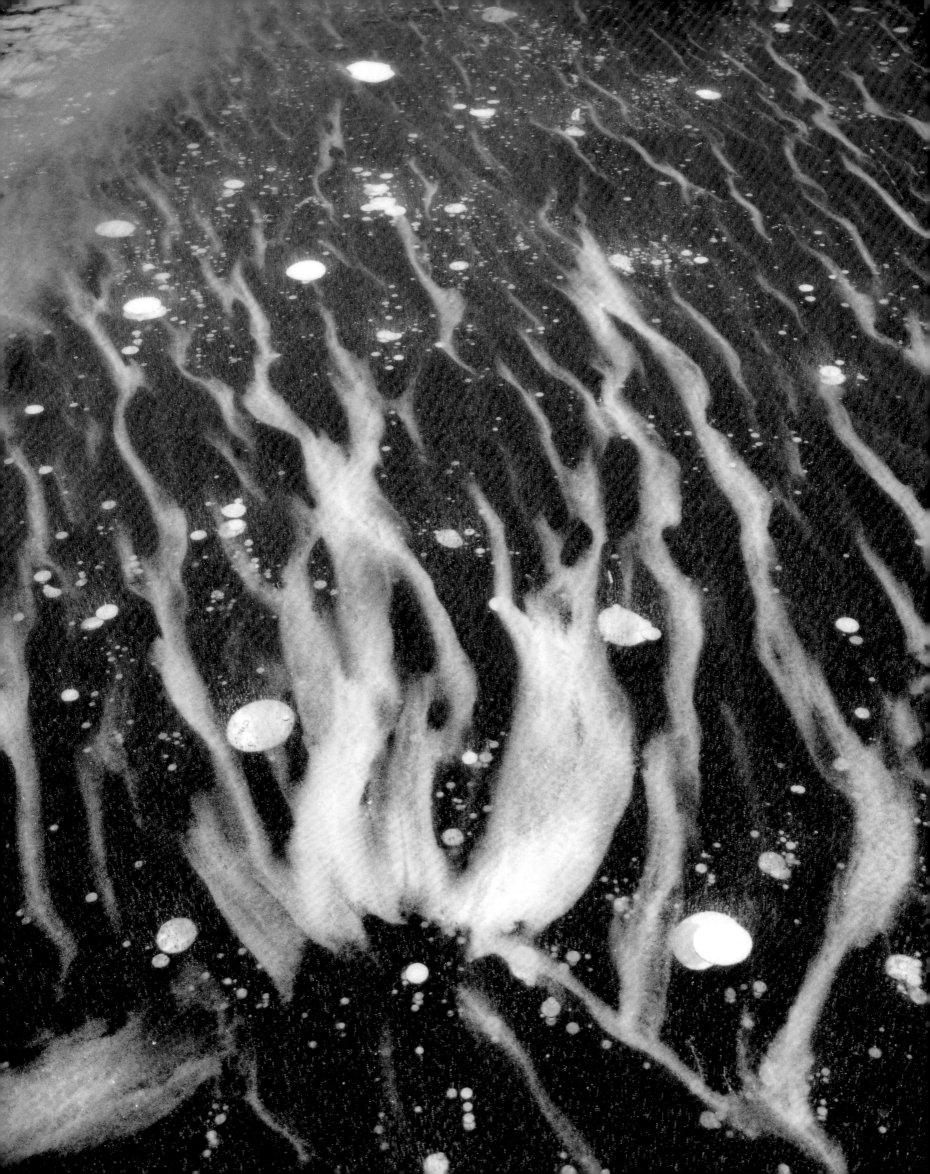

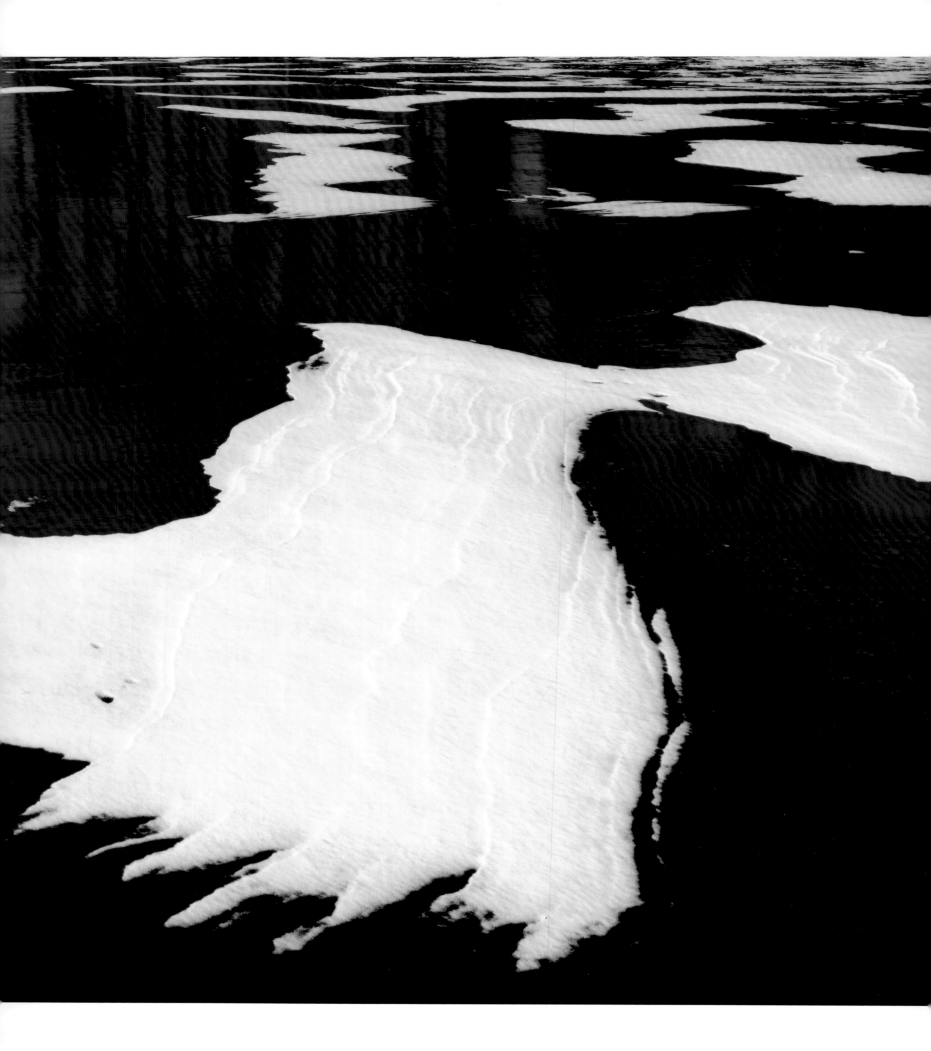

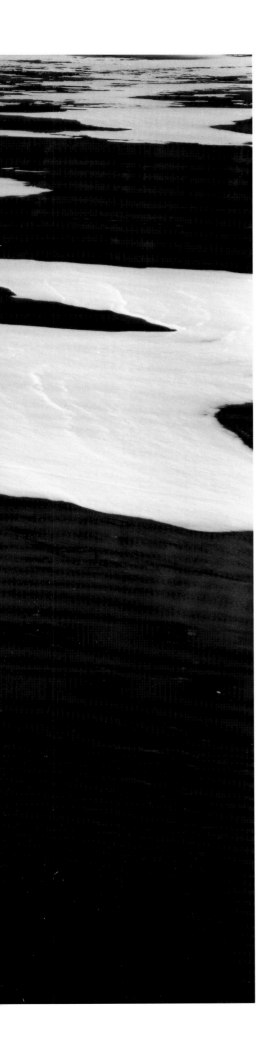

Snow Pattern #2, Pond, Ipswich, December

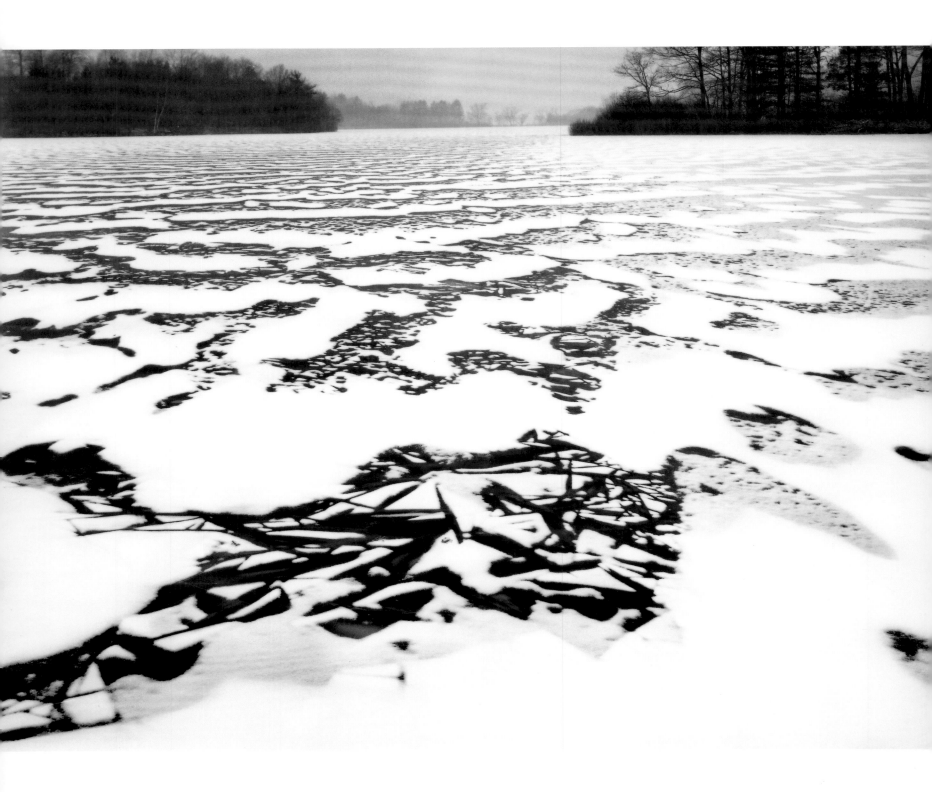

Double Wind Pattern, Pond, Ipswich, December

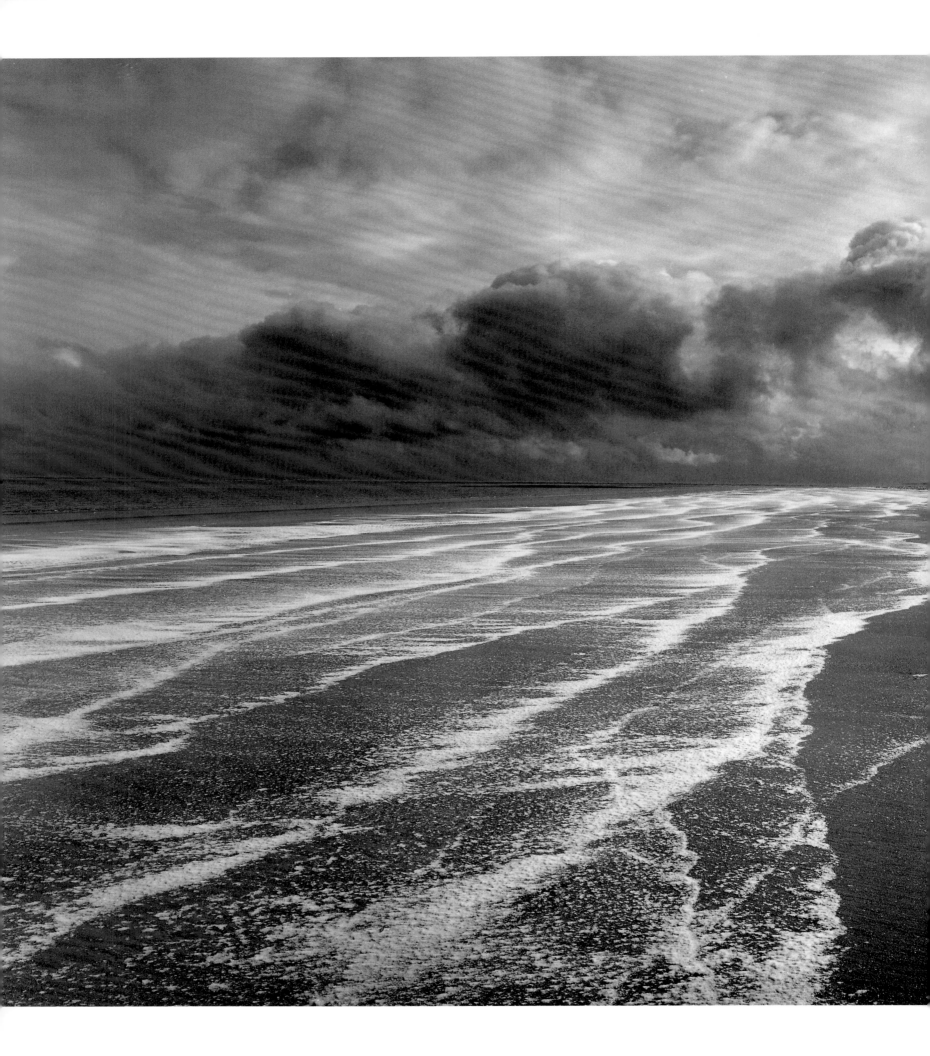

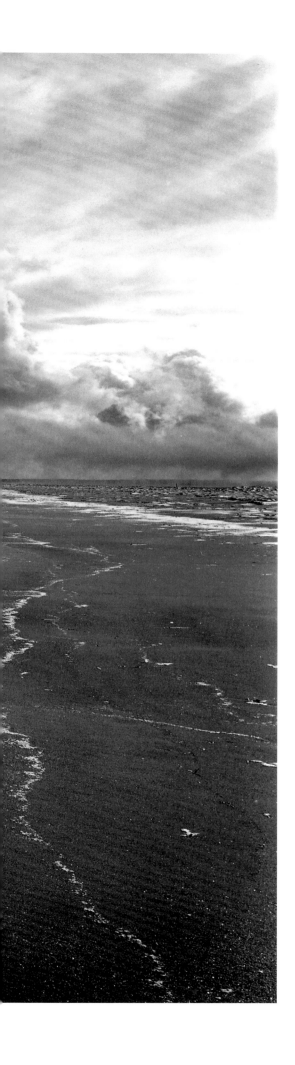

Snow Squall, Crane Beach, Ipswich, March

Dune, Early Spring, Crane Beach, Ipswich, March

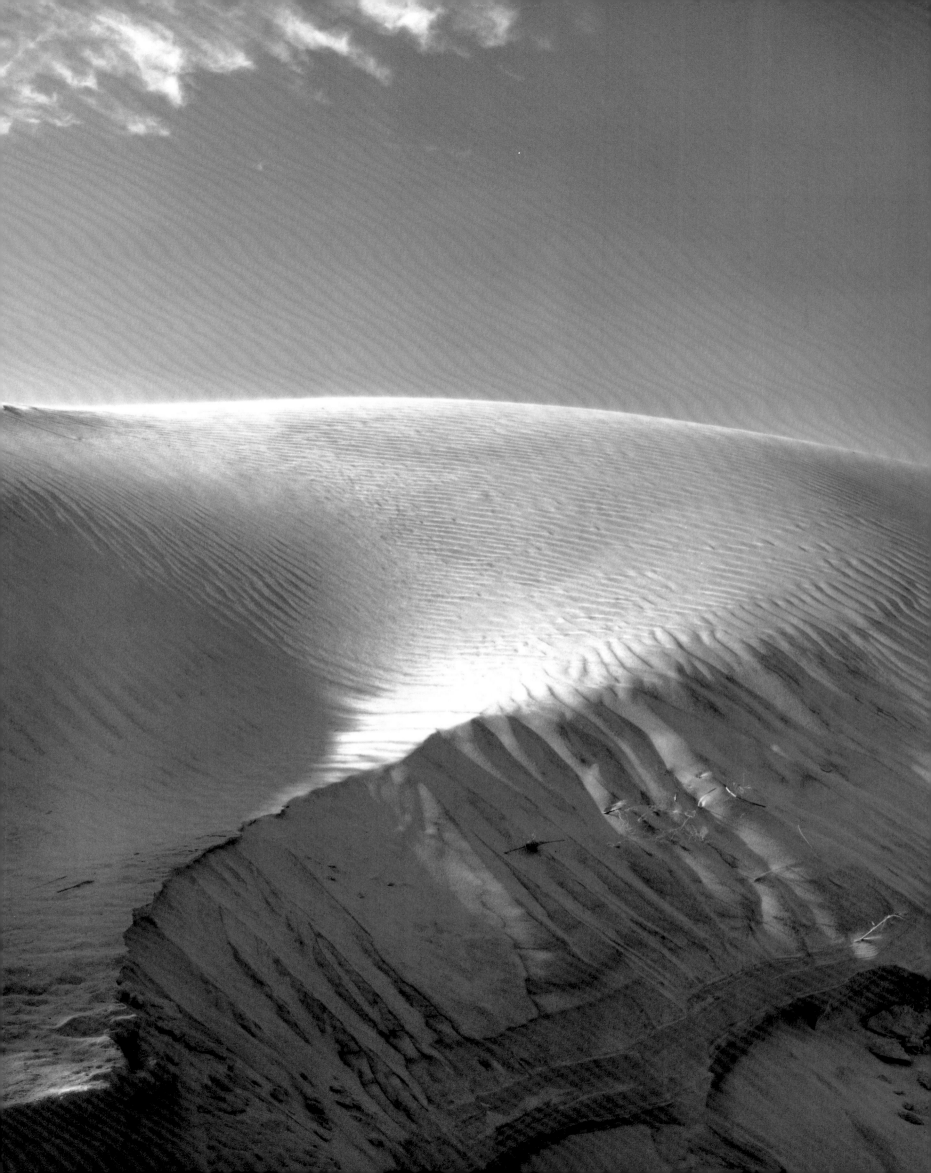

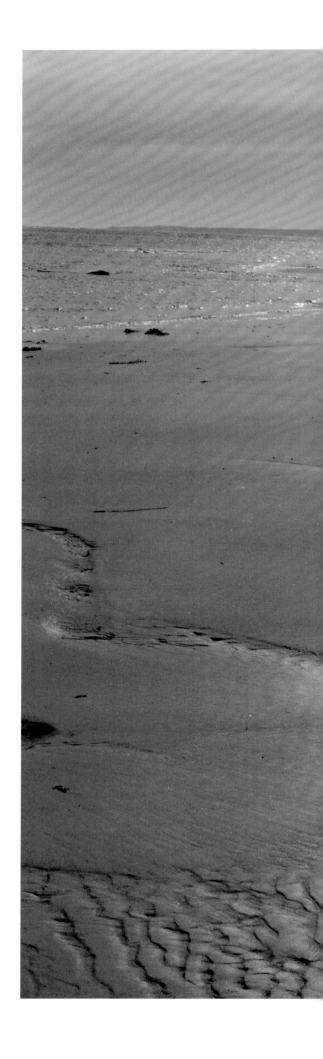

Castle Hill from Steep Hill Beach, Ipswich, September

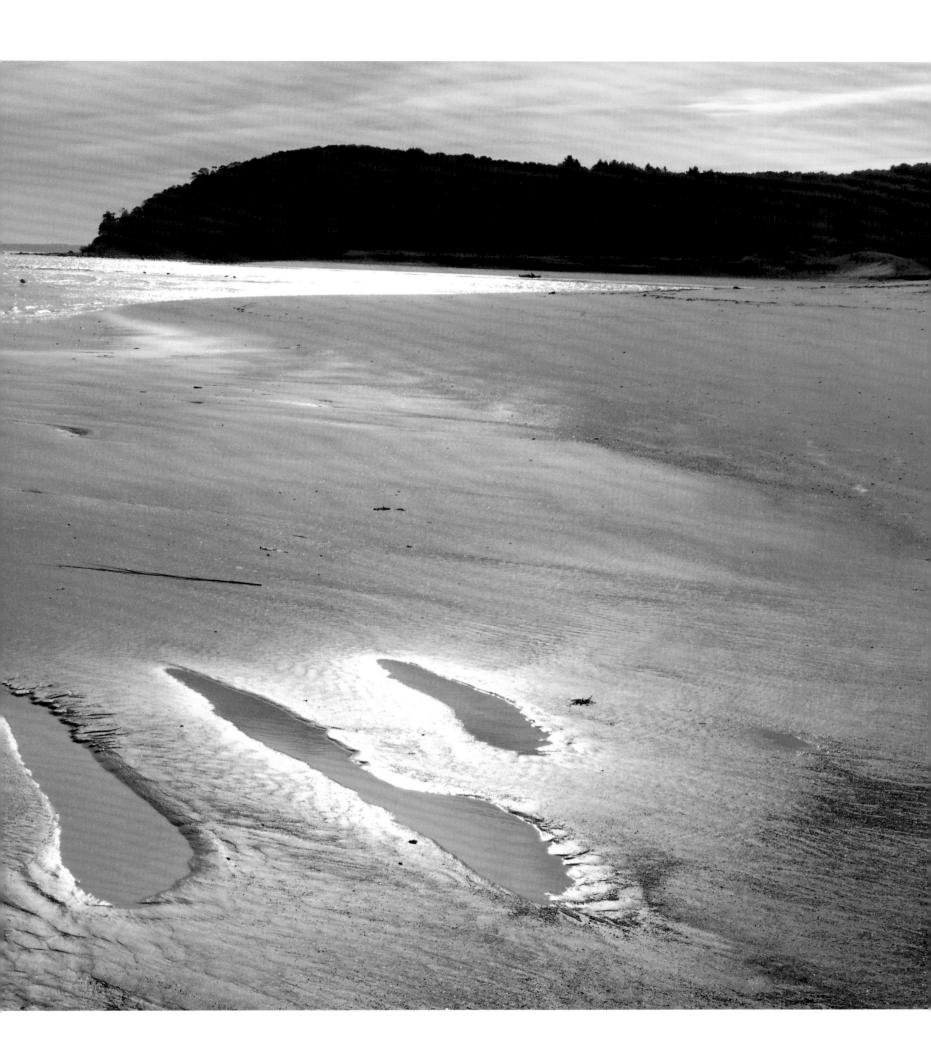

Sand Pattern #6, Crane Beach, Ipswich, February

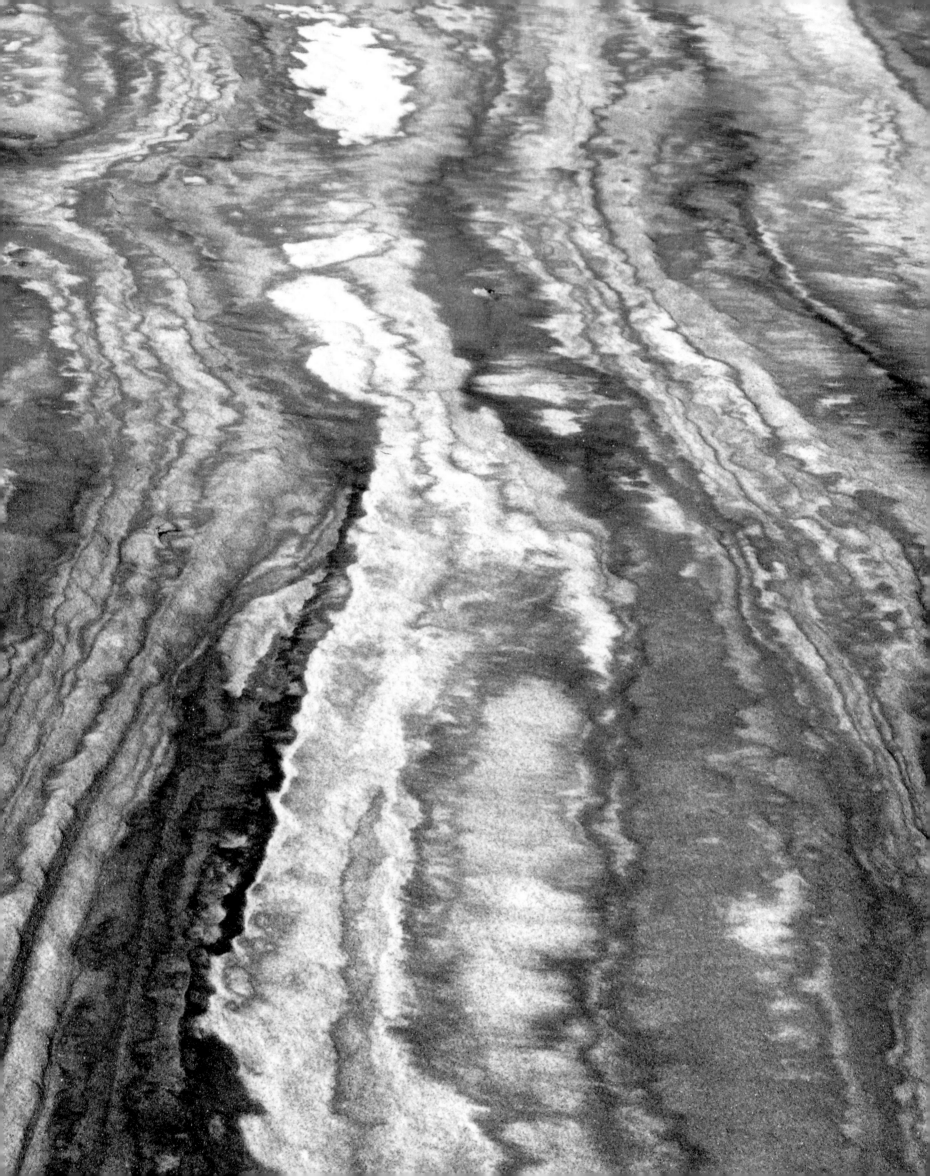

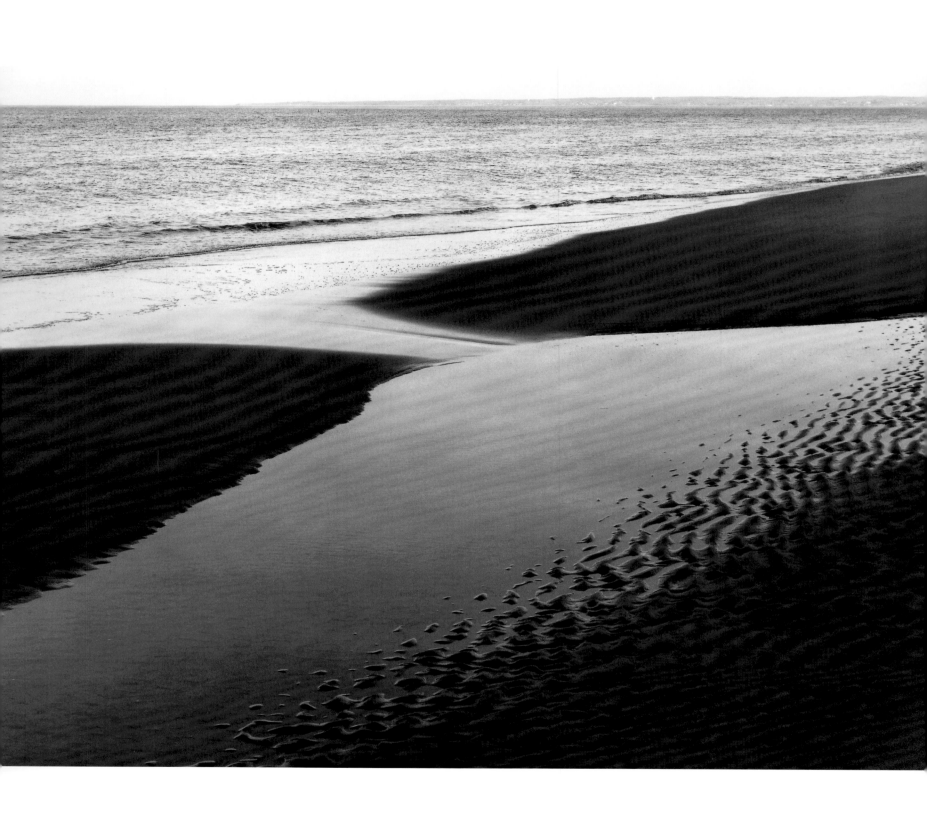

Ebbing Tide, Crane Beach, Ipswich, December

[overleaf] **Sunrise, Morning Fog #1**, Crane Beach, Ipswich, September

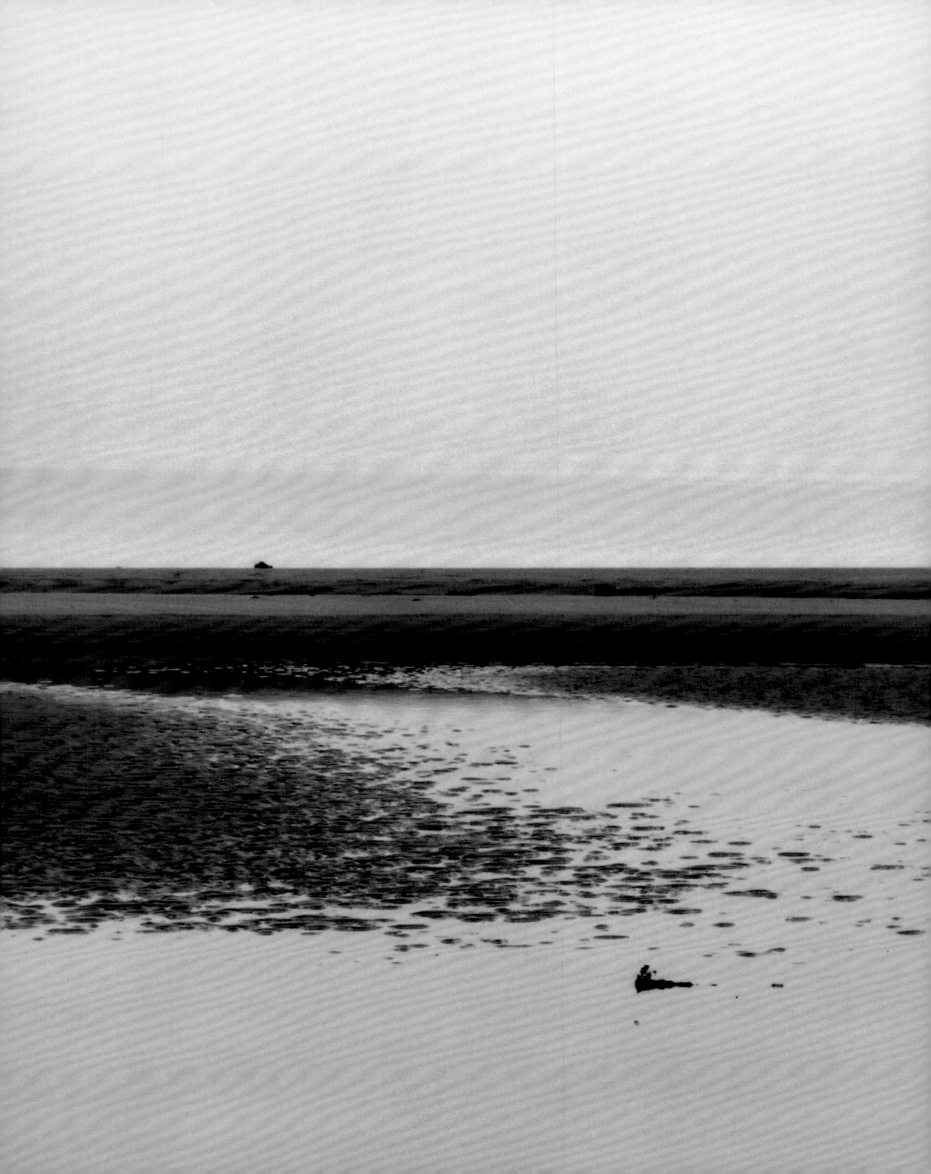

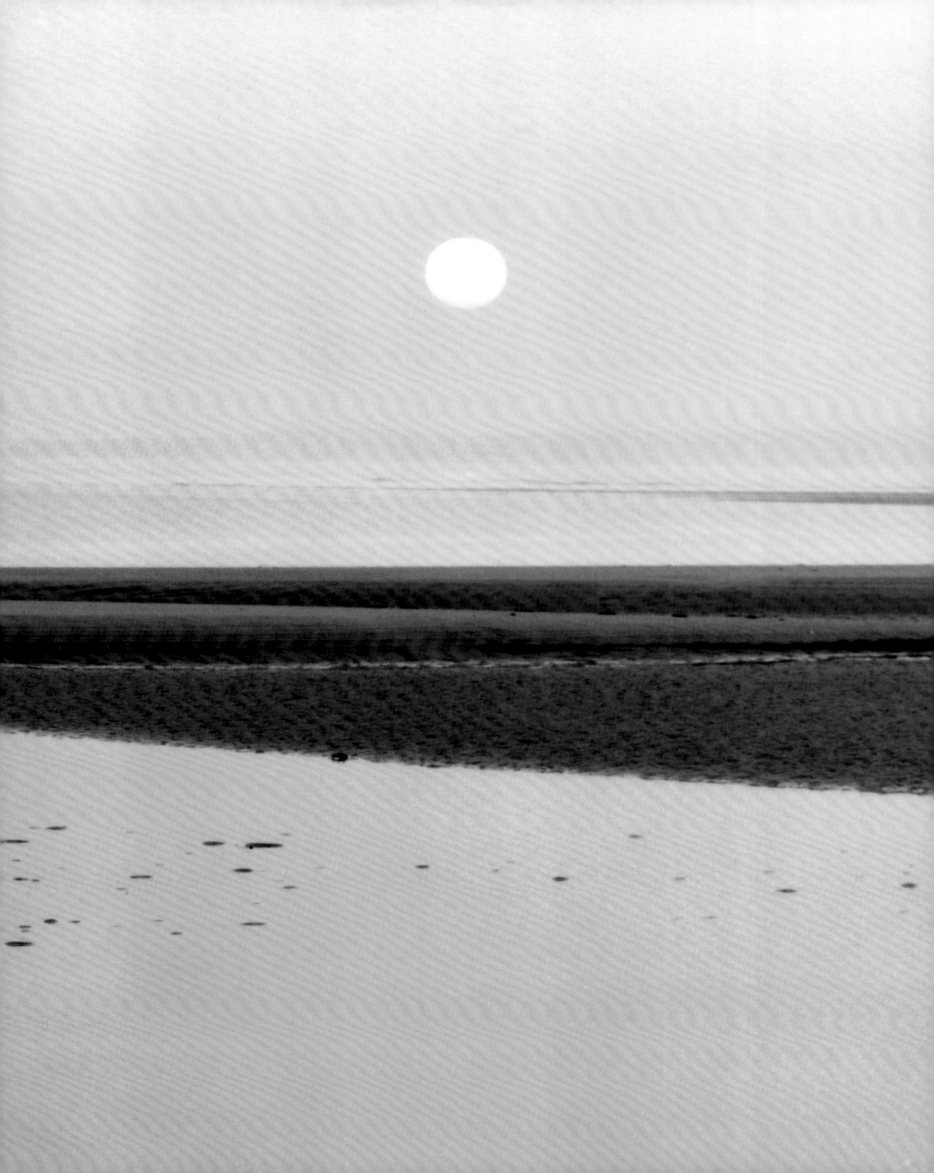

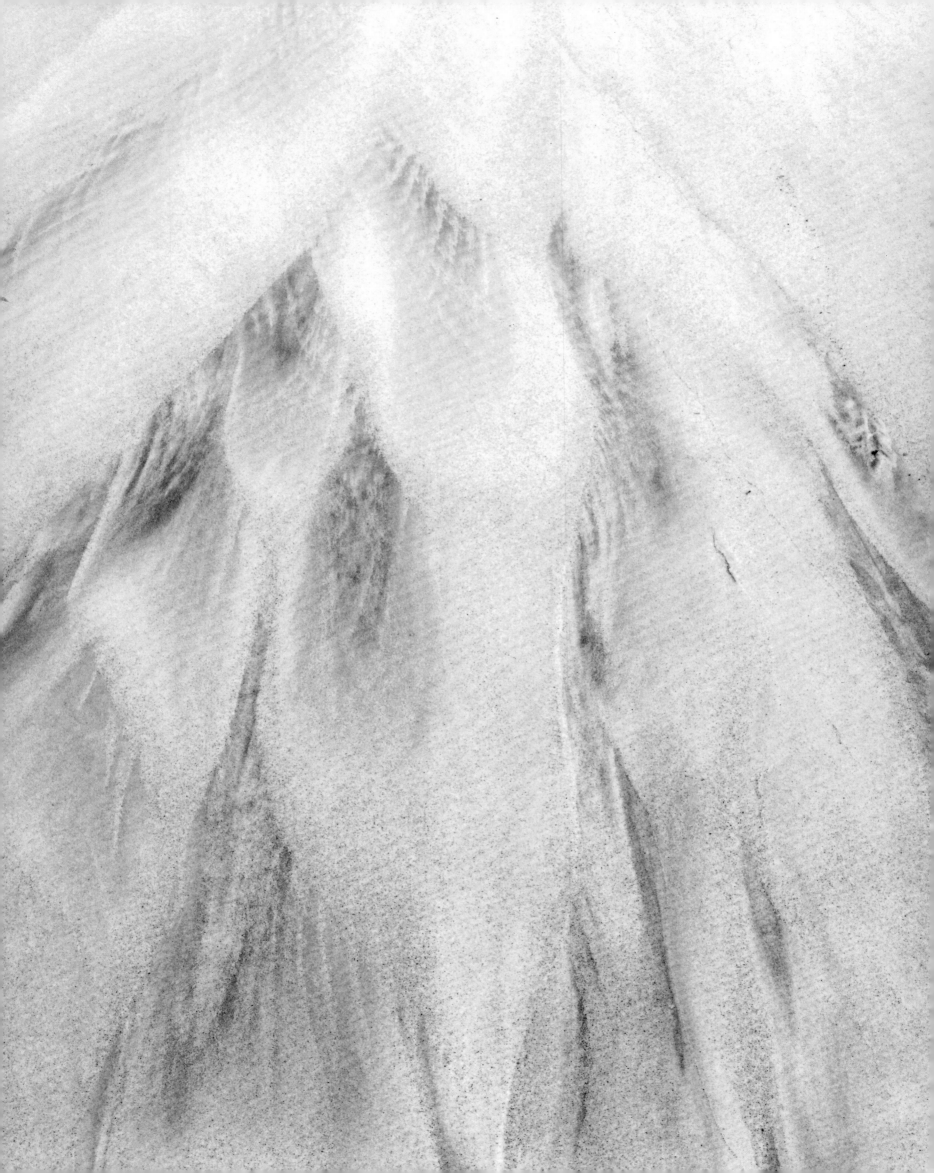

ACKNOWLEDGMENTS

My thanks to all who have contributed to this book, either through their direct assistance and generosity or by their ongoing stewardship of the Great Marsh.

I am profoundly grateful to George Braziller for giving life to *Between Land and Sea: The Great Marsh*. My heartfelt thanks to my agent, Barbara Cox, photokunst, for her unwavering support and advocacy. This book became a reality through her skillful guidance and her final edit of the photographs. It has been a pleasure to work with her throughout the process.

My sincere thanks to Jeanne Falk Adams for generously giving her time and talent to write the introduction and for making several suggestions that have strengthened the book. I truly appreciate her support, and thank her for believing in the project. My gratitude and admiration to writer Doug Stewart for his valuable contribution to this book. I am especially pleased to share these pages with one who is so well acquainted with the Great Marsh landscape. I am indebted to designer John Hubbard of Marquand Books in Seattle, for his creative design of the book, and to editor Judy McNally for her skill and care in refining the text.

Invaluable help came from artist Melynn Allen, who scanned most of the Great Marsh images for the first time, and from painter and lecturer Nancy Mitchnick, who offered encouragement and help early in the

process. Thanks also to fellow photographers Lydia Goetze and George DeWolfe for their advice and good company. My thanks to John Sexton for strongly encouraging me to focus on my local landscape, at a workshop in 1991. Thanks also to the artists' collaborative at River Gallery in Ipswich and to my chamber chorus, Cantemus, for helping to create the thriving and stimulating arts communities we share.

I am grateful to all those organizations, individuals, and volunteers who are stewards of the Great Marsh, especially the Trustees of Reservations, who protect most of the marsh and beach in Ipswich where I have photographed for this book, as well as Essex County Greenbelt Association and Massachusetts Audubon Society: North Shore. Thanks also to numerous other organizations, agencies, and community boards who give generously of their time and expertise.

Sincere thanks to my many neighbors and friends who generously share this landscape and have allowed me to use their boardwalks and traipse through their marshes at all hours and in all seasons.

Deepest thanks to my husband, Ed, for his steady support and wisdom, and to our children, Anne and Glen, and Glen's wife, Anna-Mette, for their patient technical support, and the courage they give me. I have vivid memories of my mother's strong spirit, and of my father, who gave me my first camera, a Kodak Pony, and taught me to use it.

————————————————————————

Dorothy Kerper Monnelly